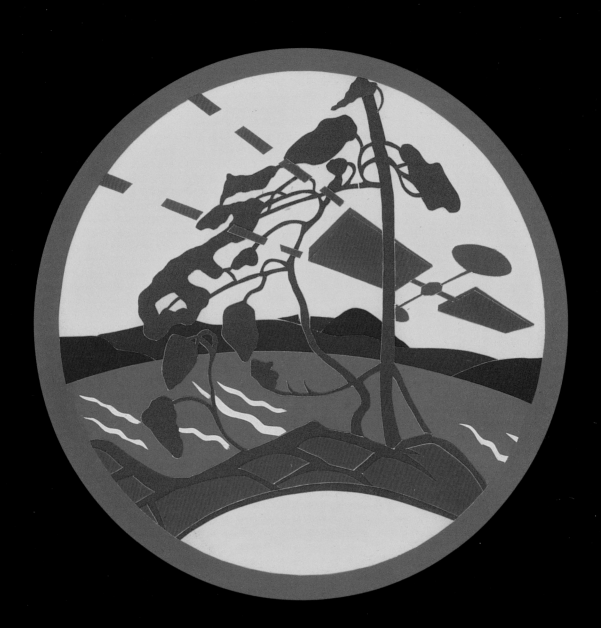

THE ART OF TIM JOCELYN

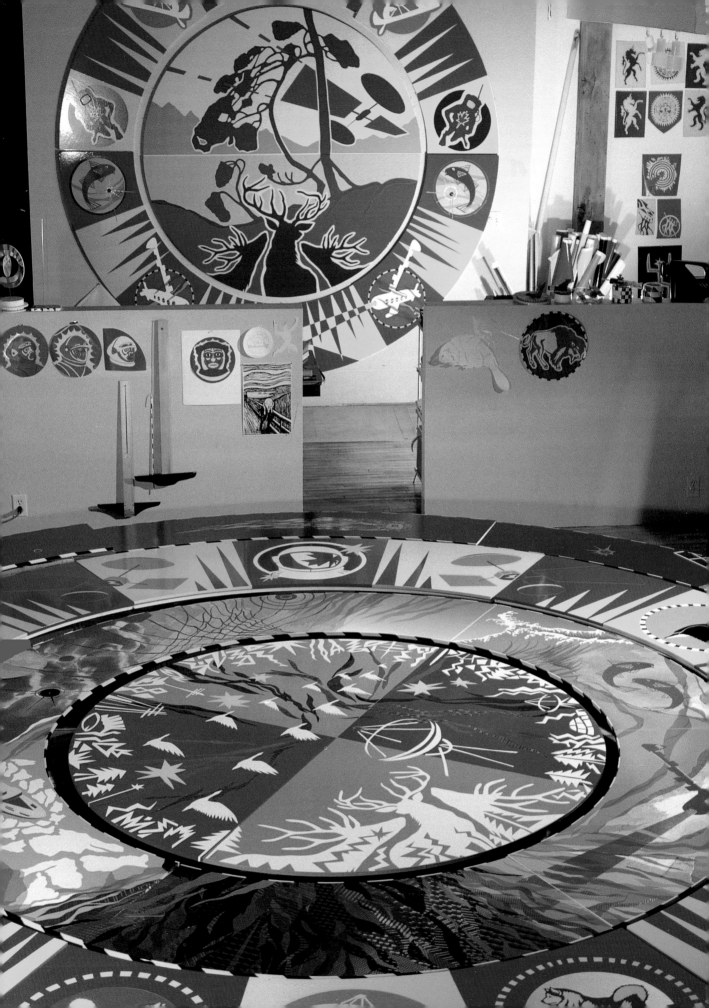

THE ART OF TIM JOCELYN

Sybil Goldstein, General Editor • Essays by Bonnie Devine, Donna Lypchuk & Stuart Reid

M&S

National Library of Canada Cataloguing in Publication Data

Main entry under title:
 The art of Tim Jocelyn

ISBN 0-7710-3368-0

 1. Jocelyn, Tim, 1952-1986. I. Goldstein, Sybil, 1954- II. Reid, Stuart, 1962-
III. Lypchuk, Donna, 1960- IV. Devine, Bonnie, 1952- V. Jocelyn, Tim, 1952-1986.

N6549.J53A78 2002 709'.2 C2001-904047-4

The Tim Jocelyn Art Foundation has posthumously titled a handful of works that Tim Jocelyn had not named himself.

Every effort has been made to give credit to the copyright holders of the photographs used in this book. Any information that makes it possible to rectify errors or omissions will be gratefully accepted by the publisher.

We acknowledge the financial support of the Government of Canada through the Book Publishing Industry Development Program for our publishing activities. We further acknowledge the support of the Canada Council for the Arts and the Ontario Arts Council for our publishing program.

Design: Kong Njo
Printed and bound in Canada

McClelland & Stewart Ltd.
The Canadian Publishers
481 University Avenue
Toronto, Ontario
M5G 2E9
www.mcclelland.com

1 2 3 4 5 06 05 04 03 02

Page 1: Plate 1. WEST WIND WITH SATELLITE

papercut, 8" diameter, 1985 / Photo: Michael Rafelson / Collection: Art Gallery of Ontario, Toronto

Page 2: Plate 2. NEW DIMENSIONS ASTROLABE

work in progress, 1986 / Photo: Tony Wilson / Collection: Museum of Contemporary Canadian Art, Toronto / Courtesy Tim Jocelyn Art Foundation

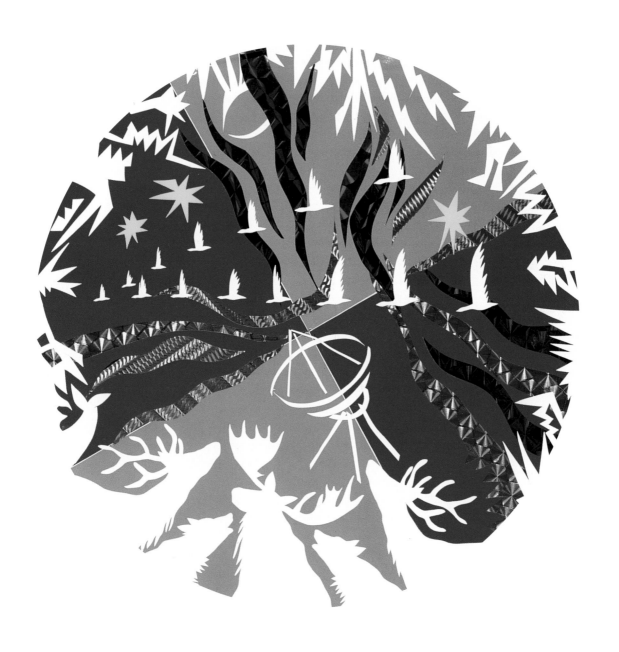

Plate 3. GEESE & SATELLITE

papercut, 13″ diameter, 1985 / Photo: Michael Rafelson / Collection: Gallery Stratford, Stratford

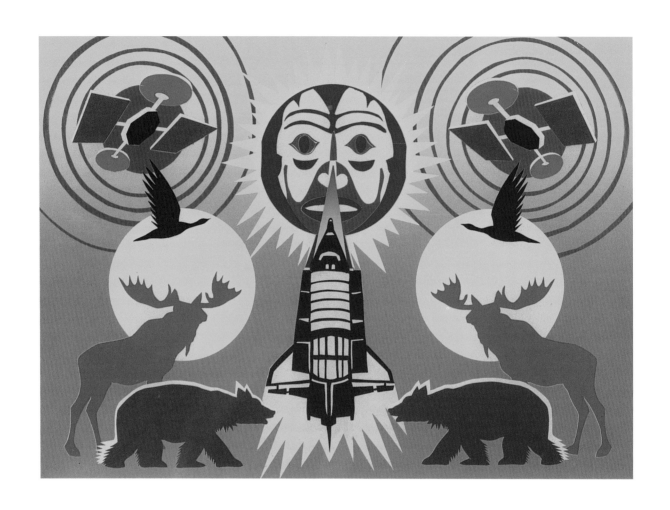

Plate 4. TWO BEAR TWO MOOSE

papercut, 15" x 20 3/4", 1985 / Photo: Michael Rafelson / Collection: Macdonald Stewart Art Centre, Guelph

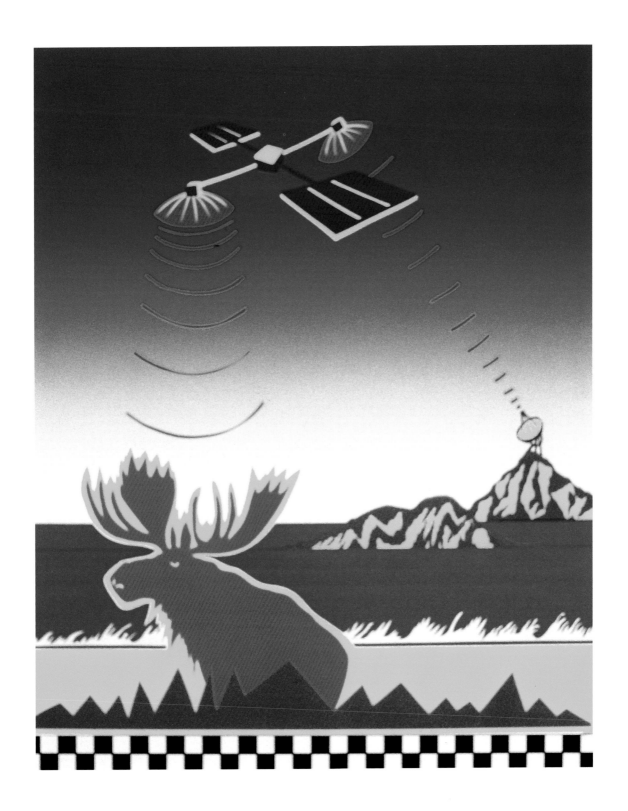

Plate 5. MOOSE & SATELLITES BEAMING

papercut, 19 1/2" x 15 3/4", 1985 / Photo: Michael Rafelson / Collection: Robert McLaughlin Art Gallery, Oshawa

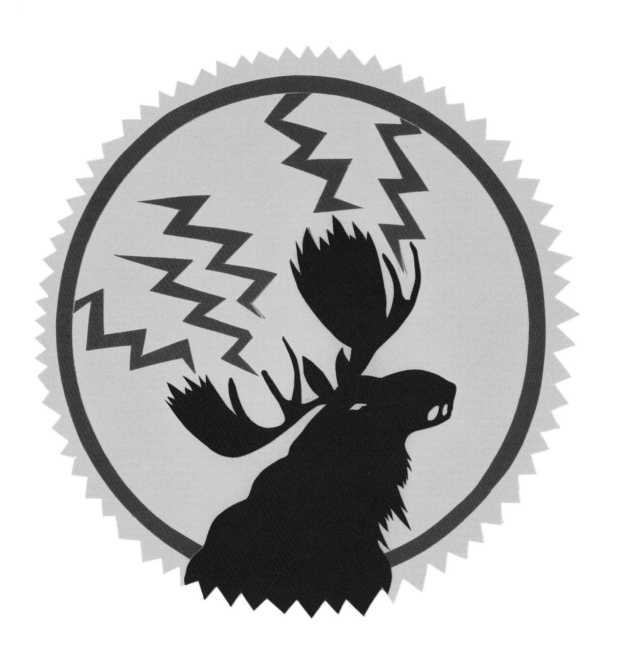

Plate 6. MOOSE ELECTRIFIED

papercut, 8" diameter, 1985 / Photo: Michael Rafelson / Collection: Art Gallery of Ontario, Toronto

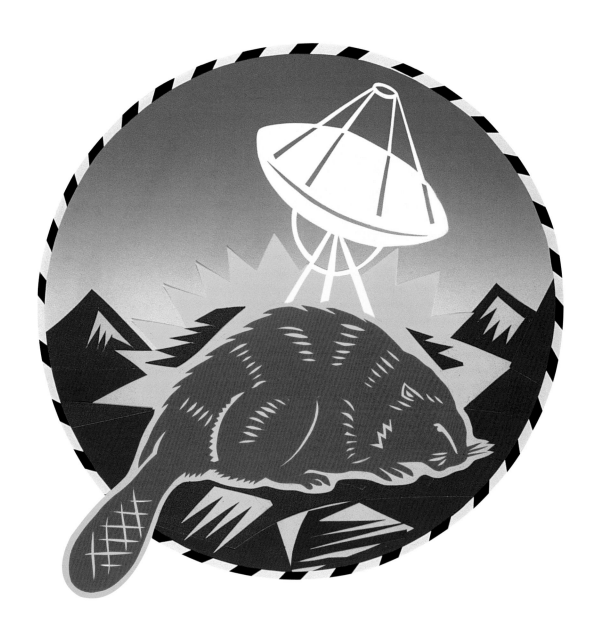

Plate 7. BEAVER & SATELLITE

foamcore and vinyl, 24" diameter, 1985 / Photo: Michael Rafelson / Collection: Art Gallery of Ontario, Toronto

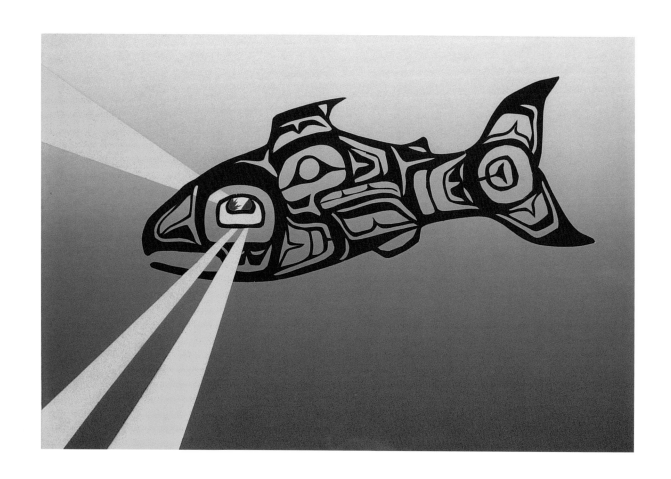

Plate 8. FISH WITH BEAMING EYE

papercut, 10 1/4" x 14 5/8", 1985 / Photo: Michael Rafelson / Collection: Macdonald Stewart Art Centre, Guelph

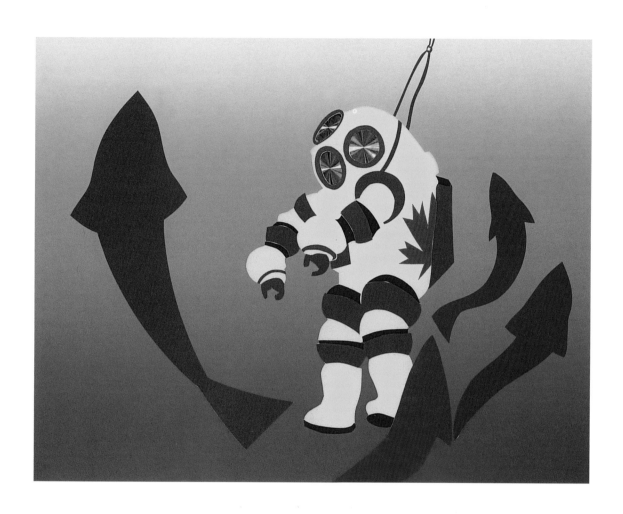

Plate 9. UNDERWATER DIVER & SHARKS

papercut, 13 3/4" x 18", 1985 / Photo: Michael Rafelson / Collection: Tim Jocelyn Art Foundation

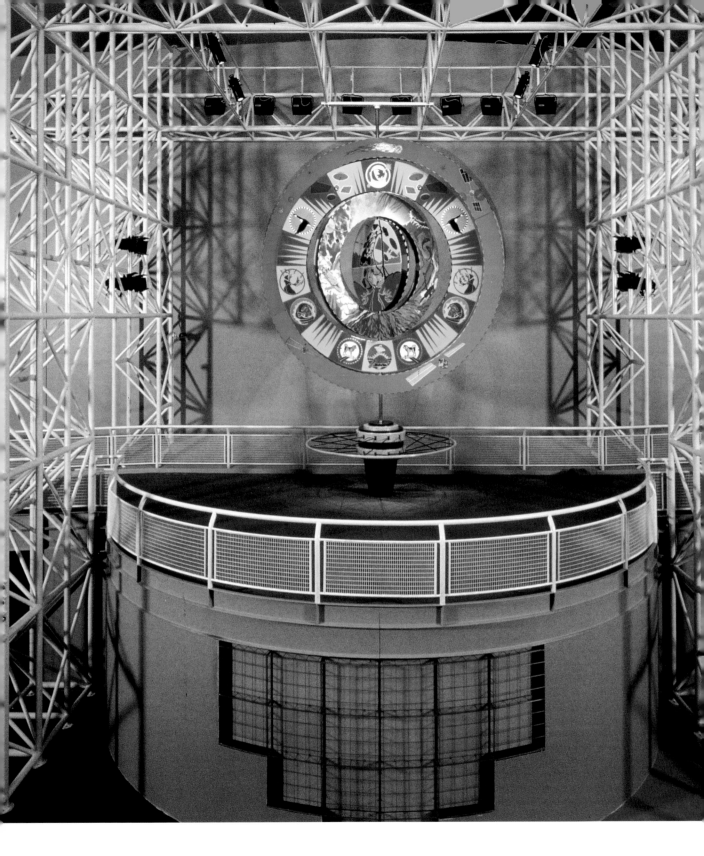

Plate 10. NEW DIMENSIONS ASTROLABE

installation in the Canadian Pavilion, Expo 86, Vancouver, B.C. / Photo: Robert Krezier / Collection: Museum of Contemporary Canadian Art, Toronto

CONTENTS

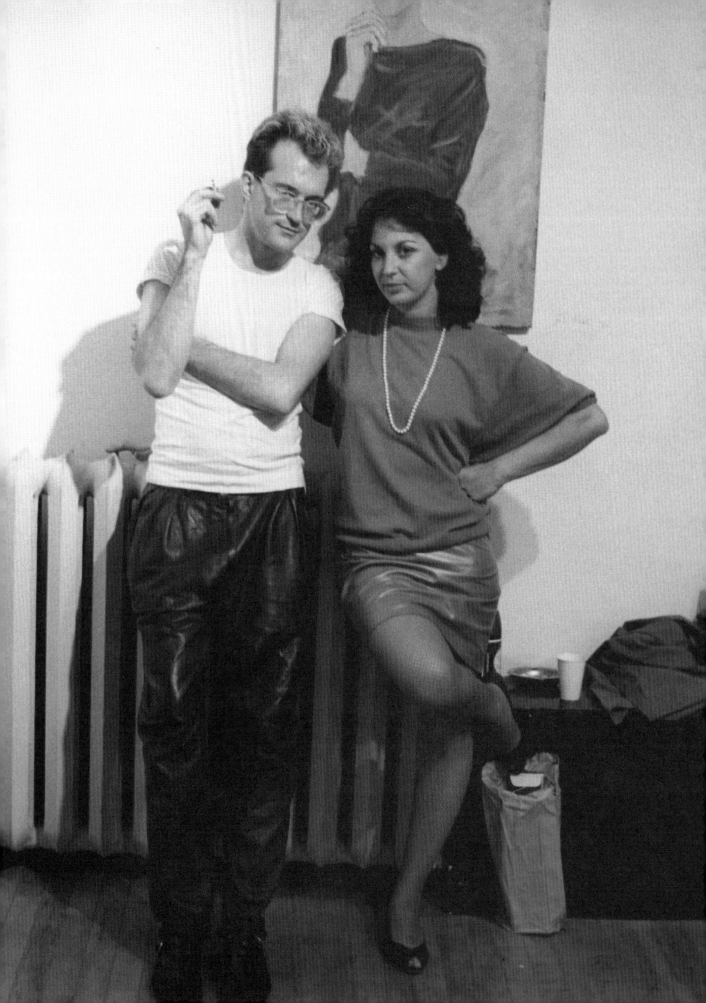

PREFACE

I don't know what happens to us when we die. I do know that what matters most is how we live our lives and the legacy we leave behind. Tim Jocelyn touched the hearts and minds of all who knew him. He was a gracious and creative artist whose provocative designs were infused with natural elegance and wit.

On behalf of the Tim Jocelyn Art Foundation I would like to express our deepest appreciation to Bill Grigsby of Reactor Art & Design for his unstinting kindness and expertise over the past decade. Thanks to Avrom Isaacs and Paul Petro for their assistance; to Alan Elder and the Power Plant; to Sarah Quinton at the Museum for Textiles for exhibiting the collection. Thanks as well to Norman Garnet of Pearson Garnet Press Ltd, for his generous support.

We thank the curators and directors whose vision has ensured that Tim's work will be enjoyed by future generations: Dennis Reid at the Art Gallery of Ontario; Stuart Reid at the Tom Thomson Memorial Art Gallery and previously at the Art Gallery of Mississauga; Janice Celine at the National Gallery of Canada; Judith Nasby at the Macdonald Stewart Art Centre; Linda Jansma at the Robert McLaughlin Gallery; Mary Misner at the Cambridge Galleries; and Robert Windrum at Gallery Stratford.

Sincerest thanks to Krystyna Ross and Jonathan Webb at McClelland & Stewart for making this project a reality.

A final thanks to Tim for all he gave. It is difficult for one artist to assess the work of another, to construct the framework within which he will be remembered, to collate the elements of his output and create the history. I have worked on this project for years, as a labour of love for someone I was honoured to call a friend. This book is a tribute to an artist whose memory and work will remain forever young.

SYBIL GOLDSTEIN

Opposite: Tim Jocelyn and Sybil Goldstein at the Sport of Painting, *1982*
Photo: Tony Wilson
Courtesy Sybil Goldstein, Toronto

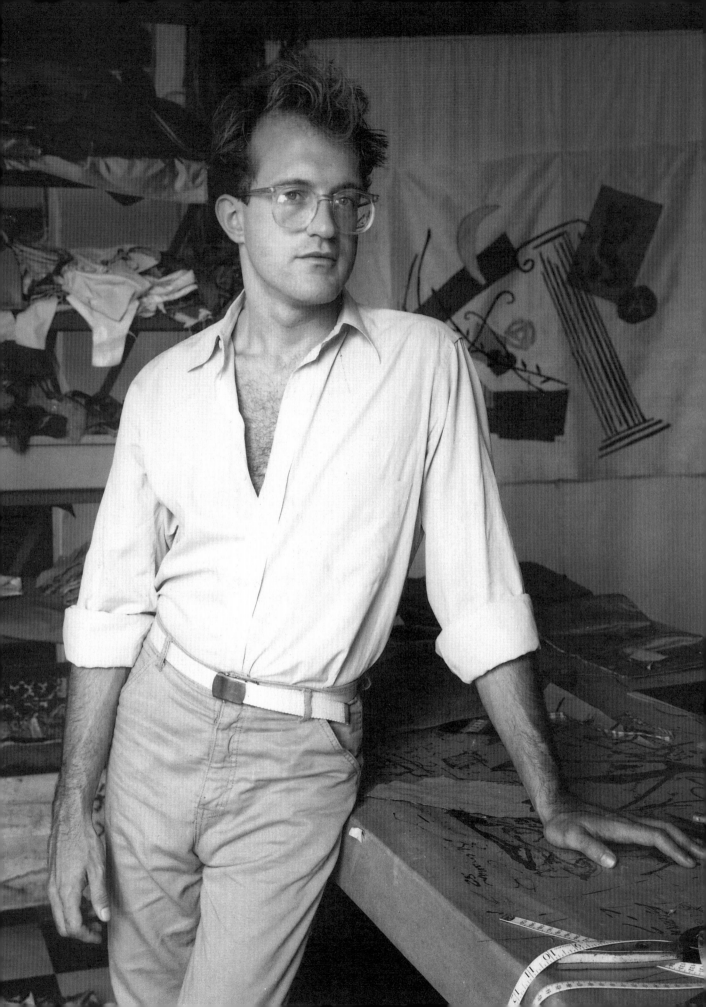

AN ARTIST'S LIFE

BONNIE DEVINE

RIDLEY GARDENS (1975-1979)

In my memory, it is a big, dusty, voluminous house. Tim lived here with his lover, Doug Brooker, and a collection of transient co-tenants when I moved into the front room on the third floor. It was a delicate, angular space, whose windows looked out on the courtyard in front and opened inward like wings over the bed. In one pointy corner, tucked under the slope of the roof, was a place for a desk and a sewing table. In the other, on the opposite side, was a small dressing room, curved under the eaves, to hold the cupboard and the clothes I'd brought.

My little boy, Sean, slept downstairs in the front bedroom. Across the landing was the dark shadow of Doug's bedroom, redolent of dougsmell: socks, woollen sweaters, and tumbled, greyed linens. Beyond that, through a glass door to a sun porch,

a potter's wheel gathered dust. The disused kitchen across the hall was to have been a darkroom, but it was gloomy and too haunted. In the end, we kept the door closed, or meant to. Sean's room had red gingham curtains and pictures of the Six-Million-Dollar Man. He was four years old when we came here, with Flora the Bear and bundles of corduroy pants and flannel pyjamas. Happy. 1976.

Tim's room was his studio and bedroom. Rows of apple baskets walled off his bed from the sewing table. The baskets were stuffed with silk fabric, scraps collected from everywhere, some beaded, some tasselled, some frayed with age and napless, all colour-sorted into a sort of jewelled laundry frame. He had arranged the colours like butterfly wings, dissected according to hue, wicker-framed. The yellows flickered in one corner. There were yellows of fire, ochre, citron and sunrise, mellow yellows, dune and mandarin, sulphur, atomic, and marigold, which shifted softly to tangerine, cantaloupe sorbet, flame and salmon. In the row above he had scrunched up peach cream, peach

Opposite: Tim Jocelyn in Richmond Street studio, 1982
Photo: Jack Shear
Courtesy Tim Jocelyn Art Foundation

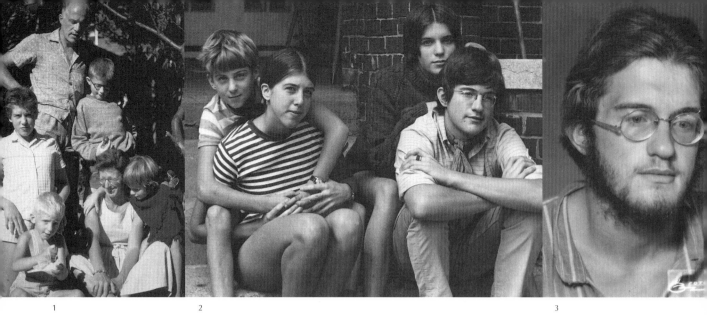

1 2 3

grey, and peach lips in a froth of satins. Above that the pinks, from blushing to brazen, crowded against flushes of geranium and nasturtium, lay open in expectant hot pouts. Then there were reds: Mao red and vermilion, blood red and red shot through with olive green, impossibly bruised, black red, red rust, maple red, midnight red, and earth. Also sand. Tim had a range of sands, from putty to ash to plush grey to dove and oyster, also mother-of-pearl and mauve clay, all in silk, warmed and moistened with pools of amethyst, sapphire, and aquamarine. He had violet moiré, crimson dupioni silk, and purple velvet à la Mary Queen of Scots. There were baskets of electric blue, indigo, cobalt, and sky in a range of crushing softnesses, chalk blue, sea blue, eye blue, glass blue and watered-down blue. There was smoke and turquoise, lily green, leaf green, transparent viridian, forest, moss, spearmint, sage, and fermenting, acid lime.

He had begged these scraps, pilfered them, or rescued them from workshops and bazaars in Toronto, Europe, and Asia. He had cut pieces from garments or costumes he had worn or found or been given. He collected them like kids collect hockey cards or archaeologists ancient, exotic bones, drawing them to him like a pied piper of colour, a practitioner of magic or magnetism, a colour gourmet. Scraps

had always been his passion. They came to him like stray cats come to certain sympathetic people, perhaps because he noticed that which was left over, that which needed to be saved.

When he was a teenager, he had gilded his bedroom ceiling until it swirled, burdened and aching, with vivid coloured fragments of magazine cutouts fitted together like panes of stained glass. A grammar. Tim's bedroom ceiling was an object of wonder in the intricacy and deliberation with which it unfolded across the arc of your vision as you lay under it looking up. Who had ever seen anything like it before? Who could have conceived this chaotic decoration? "Don't talk, just look," he said, already impatient and slightly bored by the reaction the ceiling drew. The top of his cupboard was carefully arranged too. Small bottles and squares of

1. The Jocelyn family in the garden at Neville Park, 1960.
Clockwise from top: Gordon, Tim, Marthe, Joy, Matthew, Paula
Courtesy Gordon Jocelyn, Toronto
2. The Jocelyn children on the steps at Neville Park, 1968.
From left: Matthew, Paula, Marthe, and Tim
Photo: Charles Birchard
Courtesy Gordon Jocelyn, Toronto
3. Passport photo, 1968
Courtesy Tim Jocelyn Art Foundation

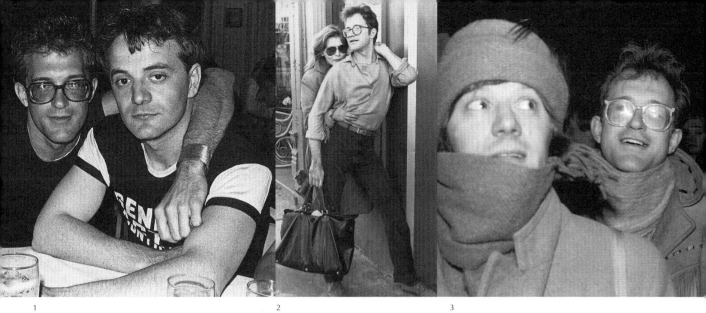

1 2 3

camphor-dusted hankies. His grandmother's dainties. He cherished all foundlings. He fondled them like graceful birds in his big knuckly hands until a sudden flash of intuition revealed their secret and indelible protocols. Then he'd arrange them.

I met Tim when he and I were fifteen. We attended the same high school in Toronto's east end. At the time he was making ornate drawings, covering his school workbooks with Walter Crane–, William Morris–, and Aubrey Beardsley–like decorations and elaborate border patterns. The margins of his books were crammed with sensuous graphic lines of a dense, fey theatricality drawn with Magic Markers. His fingers were permanently splotched and stained with indelible ink. At this time he was not much concerned with colour. These drawings referred to the linear woodblock prints from late-Victorian illustration and book design. Later, straight-limbed, stylized girl figures in angular postures and outlandish garments were introduced. He drew these in stiffly billowing dresses adapted from Russian Cossack blouses or bulkily layered bathing costumes from America at the turn of the twentieth century, imagined as streetwear for young innocents or party clothes for some waif. Possibly, me. I sewed some of these for myself after foraging for fabrics and trims with

Tim in the local fabric store, Mimi's Sewing Basket on Kingston Road, and wore them to school. As far as I know, these home-sewn clothes were the first public exhibitions of his work.

In Tim's room under the eaves at Ridley Gardens, there were three big, gabled windows looking out over the roofs to the east. They let in a rich, wholesome daylight regardless of the weather. He slept there and worked there and spent hours on the phone there gossiping with friends in his throaty, big-tongued voice. He kept up a complex network of connections over the telephone, planning his social life, airing ideas, trying on language from books he had been reading, or new music he had heard, or people he had met. He was busy and enthusiastic, knowledgeable and well-spoken, with an epicurean, even haughty taste for fine things. His discernment and bearing sometimes made a distance between

1. Tim Jocelyn and Doug Brooker, 1977
Photo: Billy Piton
Courtesy Tim Jocelyn Art Foundation
2. Tim Jocelyn and Shelley Malonowich shopping on Queen Street West, 1979
Courtesy Tim Jocelyn Art Foundation
3. Enough Is Enough, Andy Fabo and Tim Jocelyn at Bath House Raid Rally and March on Queen's Park, 1981
Photo: Duncan Buchanan

himself and the people he hung out with. Aware of this, he often compensated. Was this the root of his great compassion? As if his privilege were a thing to overcome, he developed a hunger for people and situations that were hidden, inaccessible, or perilous. As if his life had sheltered him too much, he sought access to the real world, and to the adult, unmediated truth (as if the real and true were close but always out of reach). He was always the first to step over a social or intellectual barrier, the first to laugh or shrug or speak. He was aware of people the way he was aware of colour. He delighted in the complex relations they made. He collected them. He had friends and connections everywhere: surprising connections that he handled with poise and assurance, strange connections that took him to dark, sinister places, connections drawn out of compensation and desire. It made him the most socially affluent person I knew. Magnetic and luxurious, he spent himself with joy and abandon. But his loquacious confidence could be intimidating. He was aristocratic, graceful, alarmingly well read, intellectually engaged, challenging, and very funny. He was up on everything – new music, new books, the latest fabulous short story in *The New Yorker*, some great new fabric store on Queen Street, the lives of celebrities and the lives of his increasingly wide circle of friends.

In 1976, Tim was twenty-four. The house we lived in was a draughty hulk at the top of a dead-end street near Toronto's High Park. In the corner of Tim's third-floor room under the eaves, there was a beat-up portable radio and an ironing board. Behind it was a well-lit desk and sewing machine. I watched as he laid out and assembled the small belts and bags he was making for Marni Grobba's shop in Yorkville. He was like a mad scientist, a master chef, and a giant fluffy-haired kid making a sandwich. He would iron a narrow slip of embroidered rust velvet, turn a tiny hem along one edge, then choose another

coloured scrap from one of the baskets behind him. Raspberry silk maybe. Something in between. Mushy apricot satin. He would lay down each bar of colour in slightly overlapping bands. Sometimes the edges where the colours met danced in thin electric fields, glowing like crazy for each other in a mystic re-enactment of radioactive combustion or ecstatic sex. Sometimes the colours shingled gently like the beach, washed up and over, lapped like coloured slate, pink, grey, and chromium blue. At first, the designs he made were geometric, grid-like, built around a central diamond or triangle or pentagram of colour with no underlying field or base to unify or ground them. These compositions grew from the centre out, relational, like a buttercup, graduated like a bacterial culture, rippling like an eye of God. Later, they were landscapes, an undulation of tawny mountains, a modulation of desert; finally, a register of shadows. He worked in the afternoons and late into the nights. He worked every day. The stylish customers in Marni Grobba's tony Yorkville boutique ate up the belts, bags, and sashes like costly exotic fruit. Marni encouraged Tim to build up the small, abstract fashion accessories to hand-appliquéd vests, jackets, and coats. By 1978 and 1979 he was supplying Fusion and Creeds in uptown Toronto, and Julie, a wearable-art gallery in Manhattan.

KATHMANDU (1970-1971)

In October 1971, when he was nineteen, Tim arrived in Nepal – the Kingdom of Saints, as he called it in his letters. Through a mysterious combination of drive and surrender, he made the year-long journey over land from England, negotiating his way across the ancient face of the Mediterranean and the Middle East, largely on his own, often with very little money. It started on a family vacation from New

York by cruise ship to England and Scotland in August 1970. When the family went home, Tim stayed on in London, where he worked at a series of menial jobs. He lived for several months in a communal household of itinerant Canadians on Rylett Road, gathering momentum perhaps, formulating a trajectory, which pointed always to the East, amassing the charge he required to step out of the known. After protracted stays in England and Greece he either had what he needed or released what he no longer needed and headed for Turkey.

The journey seemed Rabelaisian to his school friends in Toronto. Its excess and hilarity were detailed in the voluminous letters he wrote them. Peopled with characters he met along the way, woven through with scraps of travelogue, richly embossed with descriptions of landscape and love affairs, the letters enriched their recipients and transformed Tim into something of a legend. Later he would become Icarus, but in his travels he was Mercury in sandals and flowing cotton tunics. Intrepid and frail, he seemed to stride in a mythic place. Friends from England and Canada joined him for weeks, sometimes months, in Greece and Turkey. A pair of Jewish girls he had met on the ship from New York, Fran and Esther, turned up in Crete and then again in Skiathos. Margaret in August, with whom he won first prize dancing at the Skuna Discotheque, came from England. A lover from Toronto, Charlene, joined him in Greece for a couple of months then abruptly left to join a community of Bikkhu disciples somewhere in France or Vancouver. Tim wrote that in a last fearsome tirade before leaving she had called him "foolish, trendy, sick, weak, selfish, and vain,"[1] and told him he was moving in a possibly fatal direction. She had dreamt of Tim's death in lurid melancholy surroundings. She told him the dream, fastened it like a black rose to his shoulder, and left. It was his last significant heterosexual relationship.

These and other characters, carefully drawn, minutely documented, inhabited his letters. They provided the context and occasion for the long passages of evolving doubt, self-examination, and spiritual experimentation which typified Tim's conversation and writing. Eventually, in the company of a loose band of hippie travellers, he crossed the mountains out of Europe from Istanbul to Kandahar, heading east, spinning as he went a protracted, diverse, and multi-layered document of growth and discovery in the letters he sent home.

The path he took was crowded. He joined the cresting wave of young nomads sweeping across the continent from England to Greece to Turkey and over the great deserts of the Middle East. In all he spent fourteen months on the road in a Kerouac daydream wagon train, meandering, careening, jostling, sometimes dozing, yet more often intent and alert. During the journey he experimented with every hallucinogenic drug known to his high-school friends in Toronto and joyously tasted, as each was offered, every attitude and gesture of love. "Am now bisexual," he wrote casually in June. "Spent a night in a hotel with this fag named Barclay."[2] The admission was devoid of explanation, buried in the verbiage surrounding it. Plain speak.

He washed up at last against the grey contoured precision of the Himalayas. The "native land of holy men, madmen, visionaries," he called it, "the breeding ground of elves, magicians, fairy princesses, astrologers, architects of the apocalypse, old dharma bums, babbling saddhus, beaming bhoddhisatvas with shaved blond hair."[3] Love figures large in his letters from then. Love centred his emotions, and provided a foundation for his curiosity, daring, and reverence. I see this now when only glamour and outrageous adventurism were apparent to me then. By the time he slid into the house in Kathmandu Valley, borne on a twelve-hour opium bus ride from the Indian border, his letters had

become an eloquent, rich, and enigmatic fabric. He illuminated these pages with elaborate designs, complex borders, and tiny, funny drawings, mailed them in densely inscribed envelopes, so busy and lush that one British postmistress called her workmates over to gape. Tim's letters were beautiful. They were written with awe and irreverence together, jumbled up in elegance and sordidness both, heavy with intense observation.

In Kathmandu, the upstairs windows looked east over pagodas, smokestacks, and thatched roofs. Silks, tassels, and shawls mingled with the strains of flutes and the stench of swarms of holy monkeys. He lived with Suzie from Seattle, Dave from Texas, and a Danish guy, unnamed, who stayed for a while and then moved on. They ate, drank, and smoked enormous chillums in the tearoom downstairs. Imagine their mud-walled house, perched on the side of the magical valley, alive with moon-faced girls, smiling crones, and Hindu beggars chanting shivas in the ditches between the terraced farms. His letters describe grotesqueries of poverty and ecstasy. Wasn't it here that he learned to carve people like bas-relief figures, cutouts in primary colours, flattened against the jumbled background of a shifting geography, mottled and glowing and silk?

Geography! The mystery of transit! The strange realization that there is always somewhere else somewhere else, and you can get there. That there is always something going on and you can get in on it. He would watch in silence as daylight descended into the valley and the city emerged in layers. Turquoise stepped down to steel blue then purple, in bars like music, towards the moist heat of the mountain's navel. He began his letters always with the proper names of places. Skiathos, Teheran, Istanbul, Benares. He loved it that he was providing the travelogue of a lifetime, that it would be collected, that he would be remembered, through it, past himself. But here in Kathmandu, with two hundred rupees in his pocket, thin and tall and raked by the harsh, hot wind, wearing his Punjabi pants with the bright pink patches, he began to write about paintboxes.

In London he had seen the Tate Gallery: William Blake and the Pre-Raphaelites. From London he had written about William Morris. In the mist-washed London landscape, amid the seas of grey architecture and nineteenth-century post-industrial hustle, with the Incredible String Band jiving in the background, he had never wished for paints. Perhaps there was about the swirl of colours, scents, and flavours of Nepal a quiver of insistence or the certitude of plenty or an intuition of enough which turned him back. However it was, he turned up in India, late in 1971. Sick and destitute, he was hospitalized in an Indian infirmary, and flown home to Toronto with the assistance of the Canadian Embassy.

He came back from the East early in 1972 inspired by the visual possibilities of material and colour, but several years would pass before he was ready to act. For two years he worked in construction as a renovator and drywall installer with a draft-dodger contractor in Toronto's Beaches district. The physical labour helped to restore his strength. His vitality slowly returned as he settled himself in Toronto's reality. He made new friends, established an enduring relationship with Doug Brooker, and came to a new appreciation of his parents as his mother, Joy, began her long, cruel struggle with cancer. Emptied and readied, in 1975 he enrolled in a general art course at Central Technical High School to study introductory drawing, painting, and design. He began with small meticulous translations of wallpaper patterns in pencil crayon and watercolour – geometrical reinscriptions of Asian textiles and William Morris–like graphic iterations. In these early exercises, colour, restrained in muted chords of grey, soft green, and mauve, is subordinate to architectural symmetry. Framed and hung in his kitchen, these drawings were the subtle articulations of an

awakening memory. After one year he dropped out of art school and began to sew. His first fabric pieces were wall hangings incorporating strips of Chinese brocade, Afghani embroidery, and other pieces of patterned, antique fabric drawn directly from the *thankas*, Buddhist prayer banners he had seen in Nepal. In 1977, his first collection of wall hangings was exhibited at Wallnuts Gallery on Queen Street West. Later the same year he showed a series of plush satin art deco cushions at the Creative Arts Centre on Dupont Street, also in Toronto. Tim's use of fabric led naturally to the construction of clothing, which began as relatively simple, boxy vests, but rapidly evolved into tailored jackets, dresses, and suits that operated simultaneously in a complex combustion of painting, sculpture, and theatre.

MARVEL PANT (1979-1982)

Late in 1979, Tim Jocelyn and Doug Brooker moved out of the big house on Ridley Gardens and into a third-storey loft downtown. Their new place extended across the entire west half of the Marvel Pant Building. Tall frosted windows looked out over the back sides of factories and sweatshops on Richmond Street. Light filtered through the windows, drifted, and became tangled in the gauze drapery Tim used to partition the space. It was a bare-floored, echoing factory space: kitchenless, bathroomless, with no closed-off place to sleep, but large enough to hold in one spacious corner the big folding tables he needed, the sewing machines, the crammed baskets of silk, suede, and leather. Across the hall and downstairs the garment industry hummed. Seamstresses and entrepreneurs passed each other on the stairs. The nondescript, brown-brick Marvel Pant Building was situated one block south of the Queen and Spadina hub, a district that

was busy and threaded deeply through with the trade and traffic of fashion. The building was not zoned for live-in tenants. Consequently, it had a delicious clandestine atmosphere after dark that seemed to delight him. He was entirely absorbed in his work by then. The cluttered attic space at Ridley Gardens, and the quiet High Park neighbourhood, had held him back somehow. In and around Queen Street West in the old half-abandoned garment-district warehouses and ratty storefronts between McCaul and Bathurst Streets, an energetic, confrontational artist quarter was forming, as artists attracted by the low rents moved into the area in large numbers. Newly established galleries, art schools, artist-run centres, and video-production factories sandwiched themselves between dusty fabric emporia and dimly lit hardware stores. Ancient public houses, bars, and restaurants welcomed the new clientele. Tim wanted and needed to be there, downtown, in the middle of things, as close as he could get to the quickening centre of his professional life.

His production was prodigious. Between 1977 and 1982, he created hundreds of garments for private and retail sale and for exhibition. He worked out his designs on handmade kraft-paper patterns, stitched the intricate appliqué work himself, and then finally handed the pieces off to a seamstress for construction. He was able to turn out two, sometimes three garments a week. Subtle florals, brash geometrics, and architectural fantasies emerged in part from his early memories of the Festival Theatre in Stratford, Ontario, where he had grown up. His family was artistic: his brother, Matthew, his sisters, Paula and Marthe, his mother, Joy, and father, Gordon, were musical, theatrical, or creative in distinctive, idiosyncratic ways. His father, musical director at the Festival Theatre when Tim was a child, let him spend hours backstage. He let him watch the fevered, magical work of the costume-makers, the intent, self-absorbed air of the

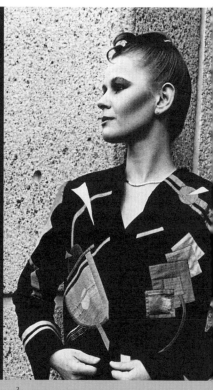

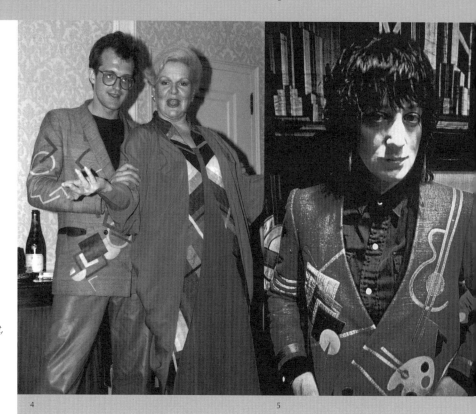

1. Bonnie Devine in pink vest, silk and velvet, 1978
2. Marthe Jocelyn in appliqué vest, silk and velvet, 1978
3. Roma Romaniuk in Constructivist Jacket, *silk and leather, 1980*
Photo: Michael Baker
4. Tim Jocelyn and Maureen Forrester, after Das Lied Von der Ende, wearing Jocelyn apparel, 1980
5. Carole Pope in appliqué jacket, silk and leather, 1980

Photos courtesy
Tim Jocelyn Art Foundation

performers preparing to go on, the bustle of expectation and barely controlled hysteria among the technicians as onstage, under the lights, a piece of theatre unfolded.

Later, as a young man travelling in the East, Tim rediscovered the mysterious pageant of rare, costly materials and his fascination with fabric, surface design, costume, and performance found a new register. The market stalls of Asia were crammed with bolts of cloth, bundles of brocade, swaths of gossamer stuff. The people in the streets, from monks in saffron robes to goatherds in pleated embroidered tunics, bore their incredible clothing not as costume but as casually and gracefully as birds wear their plumage. Why couldn't Western clothing serve as a vehicle of expression – personal, cultural, and social? Why not use clothing to decorate and beautify people and events? In North America, clothing seldom declared itself as language or art except in carefully limited places. Only theatrical costumes on stage or ritualized vestments in religious ceremony drew forth the brave individual voices he loved. From his earliest work, therefore, he played with theatricality and opulence, special occasion and its opposite, the everyday. His first vests and bags used colour, texture, and material to create an encrusted screen that snatched your attention. He incorporated Chinese and Indian silks, brocade, velvet, lace, satin, and fine leathers in his constructions. He experimented with dyeing techniques and graphic effects, allowing the influence of art deco, the constructivists, Matisse, and Sonia Delaunay to play out in a range of satin and silk objects that were both works of art and clothes. The garments Tim made in the Marvel Pant loft were gorgeous, unique, and intricately worked. At five hundred to a thousand dollars each, they sold as fast as he could make them. They attracted the notice of local fashion writers, who began to call on him for interviews and photographs. Craft-gallery curators were interested

too. Garments from a new generation of young designers then emerging in Ontario, including handmade clothing ranging from the lumpy and homespun to the exquisitely exotic, formed a significant segment of the work they exhibited.

The Ontario Crafts Council, an early and steadfast supporter, first showed Tim's work in their Dundas Street gallery in 1979, later teaming him with fellow design innovators Jane Hall, Gerald Franklin, and Barbara Klunder in a major exhibition/fashion show in 1980 called *Winter Wearables*. He had exhibited with Jane Hall earlier that year in the *New Art Wearables* show at the Grange Gallery. From the beginning he characterized himself as a "wearable artist," acknowledging the wobbly but fertile boundary between fashion, craft, and art that was to fascinate him and occupy the fashion writers who followed his development for the next four years. In an early interview for the *Globe and Mail*, Tim said, "I'm interested in fashion as an art form and individual pieces of clothing as works of art."[4] The crossover potential of fine art and graphic textile design, the notion of a fine artist transferring artistic expression and aura to a garment, and the tag line "wearable art" were quickly picked up by fashion editors in Toronto, who gave Tim favourable and frequent mention in the local press. In August 1981 he organized a show of the "new wearable art" for the Ontario Crafts Council Gallery titled *Art and Style*. He showed his own silk jackets, coats, and stoles appliquéd in suede, leather, and brocade, in addition to hand-knit sweaters by Barbara Klunder and hand-dyed, hand-painted silk gowns by Takuro Kamata. The new influence of Mariano Fortuny, whose work he had seen at the Fashion Institute of Technology in New York City earlier that year, was obvious and startling. Tim's new colours were calmer, subtler; the design was sparer with a new brevity and symmetry; his shapes were less structured. These were elegant garments to be wrapped

and draped, a classical line he combined with ornamental floral and bird motifs. At the Harbourfront *Fashion Art '81* show in November he dramatically re-articulated this new direction in pewter, copper, and bronze appliquéd silks. His prices had soared by then to twenty-five hundred dollars for a full-skirted hoop and crinoline ball gown in grey dupioni silk. "Jocelyn's work definitely falls into the Art as Investment category," wrote Christine Downs in the Montreal *Gazette*.[5]

The intersection at Spadina Avenue and Queen Street West was a metaphoric plexus then as it is even now. It drew diverse energies together, and then spun them off into business enterprises, artistic adventures, confabulations, dreams. As he lived and worked in the Marvel Pant Building, Tim's already wide social and intellectual circle expanded. He met Andy Fabo, a painter, early in 1981, and with him began a rich intellectual and aesthetic exchange that over the next five years gradually reoriented the trajectory of Tim's professional and personal life. In September 1981, Fabo, with artists Oliver Girling, Rae Johnson, Hans-Peter Marti, Steve Niblock, and Brian Burnett, established the ChromaZone/Chromatique collective. Housed in a small upstairs room at 320 Spadina Avenue, the ChromaZone gallery provided an independent, non-government-funded venue for the presentation of new work by artists using traditional forms – painting, drawing, and sculpture – to examine contemporary themes: work, play, and domesticity. Within months the group coalesced around a core of six members when Sybil Goldstein and Tony Wilson replaced Niblock and Burnett. Together these artists proposed a non-profit downtown alternative to the commercial galleries in uptown Toronto and an independent response to the artist-run parallel galleries, A Space, YYZ, and Mercer Union. ChromaZone promoted the representation and expression of visual imagery drawn from artists' real lives, in opposition to the cool, minimalist conceptualism of

the sixties and seventies. From its inception the group programmed special events such as poetry readings, music, and artists' talks along with group shows of emerging and established painters, sculptors, and performance artists. Openings were celebrations that turned into ecstatic dance parties, where grooving bodies were crammed into the tiny salon.[6] ChromaZone's inaugural show, *Mondo Chroma*, opened on September 15, 1981, to encouraging reviews. The collective's commitment to showing new work while it was "still hot"[7] resulted in a series of energetic and innovative events. ChromaZone's strengths were its spontaneity and inclusiveness, which sometimes resulted in messier, less-polished exhibitions than Toronto's gallery-going public was used to. The implied affront to prevailing aesthetic norms was a welcome side benefit as far as the artists were concerned. Their defiant spirit drew the notice of local commentators and critics, who frequently attempted to categorize the collective in complimentary, if sometimes reductive terms.[8] Though Tim was not a member of ChromaZone, his close friendship with Andy Fabo gave him access to the group's after-meeting meetings at the Cameron House, a local drinking establishment, at which coming events were discussed and creative collaborations proposed. Tim was relatively unknown in the avant-garde art scene at the time, but possessed marketing and promotional experience and professional contacts within the fashion industry that were to be of importance in the staging of several of ChromaZone's major exhibitions.

On December 18, 1981, *The Fashion Show: Jaywalking the Intersection of Fashion and Art*, the first collaborative experiment undertaken by ChromaZone and Tim Jocelyn, opened at the Theatre Centre. Billed as "a runway exhibition of Leisure Wear for the NetherZone"[9] the show presented opposing perspectives in fashion and style, counterpointing Tim's silk and leather wearable art with iconoclastic sculptor David Buchan's foam and elastic

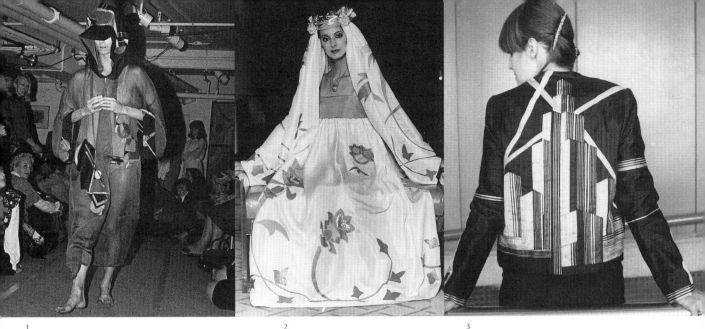

parodies of wearable sculpture. Curated by Rae Johnson but drawing heavily on Tim's energetic organizational flair, *The Fashion Show* wittily exposed several of the untidy disconnections underlying and often supporting the fashion world. It was an ambitious presentation of innovative yet essentially serious designs by Aileen Beninger, Annie Nikolajevich, and Tim Jocelyn, who had professional standing in the industry, with archly incisive counterproposals by Robert Stewart, Tanya Rosenberg, and David Buchan, performance artists and raconteurs whose concerns were decidedly other than industry-driven. In *The Fashion Show*, Tim allowed himself to explore the possibilities of satire and criticism in the practice of fashion design. If he maintained a "solicitously low profile for this show,"[10] as Marilyn Morley, fashion reporter for the *Toronto Sun,* put it in her review, it was because a radical new sensibility, challenging and even disturbing, was dawning within him.

His participation in the Clairol Fashion Awards in the spring of 1982, on the other hand, drew him back into that rigorous industry forum he knew so well. Here, far from keeping a low profile, Tim did his utmost to compete with 164 invited entrants from across Canada. Collaborating with designer

Colin Watson, Tim went into production for the competition with his usual discipline and focus, and turned out an exquisitely crafted line in his signature hand-appliquéd dupioni silk, leather, and suede. The resulting collection was outstanding. Silk jackets floated over embossed glove-leather miniskirts, tender crepe de Chine camisoles peeked beneath pieced wrappers in plum, grape, and apricot, draped over tissued silk and satin pants. He shared runner-up honours with Vancouver designer Albert Shu, while Dita Martin of Montreal took top prize: two thousand dollars and a week in Paris. The disappointment, though bravely borne, was nonetheless a turning point. While he continued to produce wearable art for special commissions and events and garments for friends and admirers, after the Clairol Fashion Awards the motivation for his production underwent a major shift. The

1. New Art Wearables, *The Grange Gallery, 1980*
Photo: Vivian Kellner
2. Bridal Gown, *silk, 1982*
3. Angelika Stahl modelling Urban Appliqué, *silk, 1980*
Photo: S. Christmas

Photos courtesy Tim Jocelyn Art Foundation

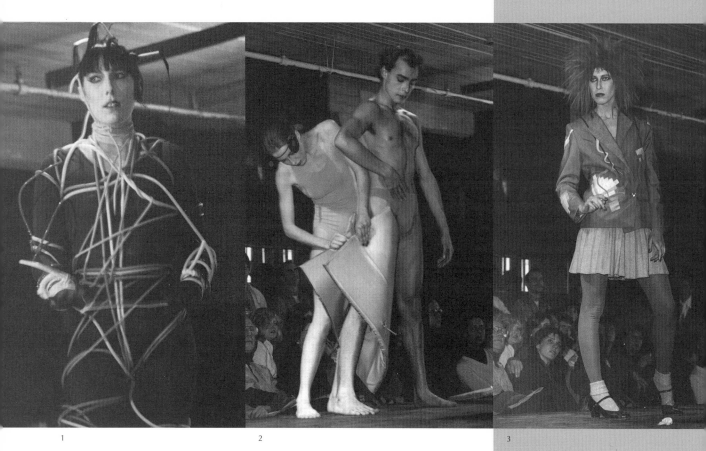

1. Rae Johnson modelling a Robert Stewart creation
2. Roger Sturge modelling Euclid by David Buchan
3. Kandinsky Jacket by Tim Jocelyn
4. Brian Burnett and Francisco Alvarez modelling Cod
Pieces by Tanya Mars

Photos: Tony Wilson
Courtesy ChromaZone, Toronto

influence of ChromaZone and its various associates had begun a process which the Clairol competition seemed to confirm. For some time he had felt uncomfortable with the fashion establishment's fervid fetishization of status, glamour, and wealth, but only now did he begin an active search for new or revised forms to develop and articulate a sturdier aesthetic position.

Things moved fast. Old companions – me among them – watched as he steered bravely out into a world removed and impossibly separate from all we had known before. From where I stood, the winds at the intersection of fashion and art seemed fierce and unnavigable. Much blew away. His ten-year affair with Doug Brooker tore clear of the mast, disentangled through a series of increasingly separate, increasingly precarious readjustments. The limits of love could not accommodate the demanding new network of relationships and collaborations Tim was anxious to negotiate. They continued as close friends but lived apart. Early in 1983 Andy Fabo moved into the Marvel Pant loft.

OOGA BOOGA LIVING (1983-1984)

Tim Jocelyn met Andy Fabo in February 1981 at The Barracks, a steambath where Fabo was working the night shift as a cashier. At the time, The Barracks was at the centre of the now notorious Toronto bathhouse raids – a series of midnight forays by the local vice squad into certain well-known gay trysting establishments. The raids, acts of legitimized homophobia and harassment, served to unify and politicize the gay community within weeks. A community born out of violence and isolation often generates compensatory pathologies in order to survive. Initial outbreaks of virulent disobedience and defiance led to organized demands for civil

recognition and human rights, ultimately resulting in the emergence of Toronto's Gay Pride movement. Otherness was exalted, fiercely defended, and often brilliantly argued. Along with anger, a long-simmering playfulness erupted in unlikely places. The ensuing explosion of creativity made collaborators out of ChromaZone, the collective founded in September 1981. Neither limited to gay members nor identified as a gay organization, ChromaZone reflected and embraced this spirit of collaboration, inclusion, and celebration. A new constellation, a busy nexus of cultural collision and collusion formed in Toronto, in which gay politics, high-society sophistication, and low-rent cheek butted heads and coalesced in a series of connected events announcing the beginnings of a new sensibility. Nothing illustrates the emerging consciousness in Tim's evolving practice better than the next project he undertook in collaboration with Andy Fabo: the Brave New World extravaganza called *Chromaliving*.

Chromaliving, presented by ChromaZone, was developed and co-curated by Tim Jocelyn and Andy Fabo, with the organizational assistance of Carla Garnet. The exposition of rooms and furniture by more than 150 artists opened on October 19, 1983, in the empty Harridges store in the Colonnade at 131 Bloor Street West. Located in the centre of Toronto's chic uptown fashion strip, the month-long event began as an exhibition of furniture and household accessories in the traditional home-show format reminiscent of the Better Living Building at the CNE. Intended to present a futuristic vision of furnishings for the modern home, the show immediately overtook its own premise by becoming a larger, more pointed parody of contemporary retailing practices, shopping behaviours, and the hilarious, sometimes chilling commodification of art and culture than even its organizers imagined. John Bentley Mays wrote that "*Chromaliving* is not a show of furniture and art merchandise. It is a show about

1. Fortuny Wrap, *silk and leather, 1981*
Photo: Carol Gibson
2. Jayme's Geometry, Spring Collection, *1981*
Photo: Deborah Samuel
3. *Jocelyn entry at the Clairol Awards,*
silk and leather, 1982

Photos courtesy Tim Jocelyn Art Foundation

furniture, about merchandising."[11] More than this, *Chromaliving* was a show about showing. For Tim Jocelyn, the timing and location of *Chromaliving* could not have been more significant. He abruptly announced in an interview with Marilyn Morley in the *Toronto Sun* that he was "bored with the fashion scene. . . . I decided to keep moving into art with fashion as a part of it,"[12] he said, apparently using the show as a vehicle with which to effect the change. Moreover, Harridges, lately a bastion of the well-heeled high-fashion social establishment whose patronage he had so hotly pursued, had recently closed, a victim of the economic recession of the early eighties. It was literally steps from the classy Yorkville boutiques that still carried Tim's clothes and catered to the rich and famous women who bought them. But he had made his break. The realm of Art, like a Good Ship Lollipop, tugged on the lines holding it at harbour. Tim jumped aboard with a joyous laugh.

Tim began embellishing seemingly random objects and apparently banal surfaces with insignia and emblematic glyphs. He covered furniture, clothing, kitchen tables and chairs with icons and totems, conjuring a parallel consciousness, imagining perhaps in the tribalized nomenclature of his imagery a fractured folklorism nattily dressed for the apocalypse. His series of costumes, houseware furnishings, screens, and banners on the Ooga Booga theme emerged from contemporaneous gay sensibilities and politics, the Brueghelesque imagery of William Burroughs, and his own fascination with doomed heroic figures from myth. The transformational potency of the creeping lizard icon created by Tom Slaughter, his friend and brother-in-law, inspired him also with its graphic intensity and amphibian dualism. He conflated Icarus with the Dancing Fool of his earliest romanticism and an imagined tribe of wild boys. After the model of the Wild Chapatoolies,[13] a musical fusion of carnival culture with cargo cult ritual from the Louisiana swampland, he and Andy Fabo attempted the construction of a faux-primitive alternative social order. The now current discourse around appropriation, historical quotation, and eclecticism notwithstanding, their Ooga Booga dance performance in December 1983 posed no immediate threat to the legitimate social and political struggles of genuinely marginalized tribal people. On the contrary, the primitivist costumes fashioned by Tim out of tinsel and foil and the disco music they danced to referred more to a specifically urban phenomenon of dislocation both had examined earlier in *Chromaliving* and in Tim's autumn exhibition at the Olga Korper Gallery.

Olga Korper gave Tim Jocelyn his first solo exhibition as a fine artist a few weeks after *Chromaliving* closed. Organized at short notice to fill a gap in her fall schedule, the two-week exhibition gave him the opportunity to reiterate issues raised in *Chromaliving* and his position vis-à-vis the fashion scene. His friends turned out at the opening party dressed in Jocelyn creations while Tim himself wore a simple silk tunic emblazoned with a heraldic Pan figure. Banners, screens, and sweatshirts in his trademark appliqué technique comprised most of the exhibition. But four new dresses constructed literally of rags and described by fashion critic David Livingstone as "irregular strips of silk joined together with zigzag stitches"[14] represented a radical departure from the meticulous construction of Tim's earlier clothes. These objects "seem more whole," Livingstone wrote. "You cannot so easily separate what makes them works of art from what makes them clothes."[15] Columns, TVs, and running, dancing boys tilt across banners and screens that defy a simple reading. Remnants of primitive and classical imagery collide in these objects, constructing an underworld narrative and a dark geography of radiant eroticism. Danger, adventure, and fear gleam through the tissues that form them. Icarus emerges

as a key persona. Icarus falling extravagantly down screens and banners, red and yellow Icarus, the Dancing Fool, a flame-lit runner. Theseus also emerges as a significant figure. He is the red-clad slayer of the Minotaur, drawer of the silken line within the maddening Labyrinth. He looms within these large-framed, bordered latitudes, parenthetical containers which fold out or open out like maps to hold Tim's visions and their expanded spatial requirements. The screens become strange metaphors for costume, persona, and mask. With the cutouts of Matisse an evident influence he melds on them elements of neo-classicism, jazz, and the post-modern. More than pictures or books, the screens are like apertures into a mythic non-time non-space, offering a new format, a canvas-like breadth, a language-framed scene, and a painterly field. In the screens Tim's work lays claim to a new dimension, extending the possibilities of narrative development, where content at last assumes equal importance with form. In the screens Tim no longer painted with fabric. He began to write.

One more gesture remained, however, before he could entirely quit the fashion world. At Harbourfront on June 21, 1984, he presented *Dressing Up*. All his gifts as organizer and impresario were brought to bear in the staging of this final extravaganza. Featuring artists posing as models dressing up, showing off, and goofing around, the show was an opportunity to both lampoon and celebrate the weird contradictions embodied in fashion and style and have a raucous party in the process. Twenty artists participated. They showed bizarre, over-wrought, usually impossible-to-wear outfits, ranging from a mermaid suit complete with scale-encrusted tail to a hockey-equipment-inspired wedding gown. Many in the audience and on stage as presenters wore Jocelyn garments, but Tim himself showed no new work in the show. He was content instead to play to the hilt the role of producer-bricoleur. As before in

Chromaliving, Tim revelled in the creative energy of the collaborative act.

In September 1984, Tim was invited to participate in an outdoor group exhibition at the Toronto Sculpture Garden on King Street East. *Visual Rhythms*, a collection of eight works inspired by music, was curated by Marshall Webb. Tim installed three large fabric banners entitled *Lizard Boys Ooga Booga* against the east wall of the courtyard space. Colourful and exuberant, this piece exemplifies his increasing facility with the cutout and the paring-down of his palette to bold, primary colours. The banners' fabric surface functions again as a screen, threshold, or multivalent sign. The banners themselves are strangely utilitarian ideograms, cunningly hinged refractions of the flat consumer language of style or logo design. Fluttering dramatically against the smoke-greyed brick of Toronto's streetscape, they seem to beckon us to enter an older, darker, less casual place. A new Byzantium.

CITIES OF THE RED NIGHT (1985-1986)

The studio at Marvel Pant was the ideal creative situation for Tim. He loved the steady traffic of visitors. He loved the audacious intellectual stimulation and the chance to be deeply involved in momentous events. Among the artists on Queen Street West at the time, the sense of moment was palpable, and Tim, striking, articulate, and charismatic, was ideally equipped to participate and, if necessary, lead. His ability, focus, and determination had made him a star within the Toronto fashion and art elite. His association with the ChromaZone collective and the ongoing challenges presented by his own creative investigations delighted him, and the warmth of his fun-loving personality ensured a frenetic and hilarious social life. The

young art community, raw, hopeful, and expectant, was running hard on momentum built of its own bravura and welcomed a rallying presence of generosity and guts. His love and his kindness, his physical presence and his sexual magnetism fed on and nourished in turn a wide array of people.

But Tim was often overburdened and occasionally overwhelmed by impossible deadlines, and his financial situation continually troubled him. He spent money compulsively, as soon as it came into his hands. He went through cash at a dangerous rate, shelling out for extravagant dinners in expensive restaurants and impulsive purchases: clothes, *objets*, fabrics, and drugs. He spent money on boyfriends, on nightclubs, on music, on sex. So, despite his success, he was often broke, and his self-assured, carefree demeanour too often hid deep anxiety and a growing sense of impending disaster. His close friends knew this. His conversation was littered with it. His behaviour, which had always veered between disciplined, painstaking commitment to work and rash, even foolhardy indulgence, could be labelled self-destructive.

This is too easy a reading of Tim's character. His life was a search more insightful than destructive. From his youth he had valued authentic feeling, even terrible pain, above the commonplaces of comfort or security. He experimented in relationships as he did in colours, looking always for the miraculous and beautiful, finding it most often in the rare, the unlikely, the dark. His search led him, in the early seventies, to primal therapy, a radical form of intense self-examination by which he uprooted the network connecting his deepest relationships, the better to respect and deal fairly with those he most loved. He pressed to the end of his life the limits of his intelligence, his body, and his art, transforming the Tibetan Buddhist dictum "do no harm" into a personal practice of doing everyone he encountered some good.[16] It was an exhausting practice, an expensive practice, ultimately, a practice of love.

His search led him to strange cities. They glowed in his imagination and in the words and pictures he made about them: Istanbul, Kandahar, London, Kathmandu. And ever, New York City, which had a special attraction, for in it he perceived a particular New World consciousness, both glamorous and foreign. All his life the prospect of New York, the phantasm of New York, had inspired a tremendous and unremitting ambition in him. People were smarter in New York City, Tim liked to believe. At least they were hipper. Art and culture were possible there. In New York people knew the truth of things. They knew that although life is large and people small, New Yorkers are never as small as people elsewhere. When Andy Fabo received a Canada Council grant to work for a year at the P.S.1 Studio in New York City, Tim was ecstatic. Here was his chance to take on the art world from a position right at the centre of its many-towered heart.

They packed up the Marvel Pant studio in August 1984 and he, Andy, and Gordon LeBret, an artist friend they'd hooked up with for the trip, drove a cube van containing all their belongings to the Quebec-Vermont border. After a series of mishaps at the U.S. customs office, which culminated in the destruction of the "Welcome to the United States of America" sign when Gordon left the parking brake off, they made it into the U.S.A. Later that day they took a wrong turn within sight of the New York City skyline, wound up on a stretch of restricted roadway, and had to rattle hair-raisingly across the Hudson River on a half-finished bridge into Manhattan. Tim and Andy installed their equipment at the P.S.1 Studio, then found a small loft at 26th and 10th in Manhattan, a funky enclave not far from what is now the gay ghetto of Chelsea. Their building, across the street from a hip-hop club called the Fun House, close to the Empire

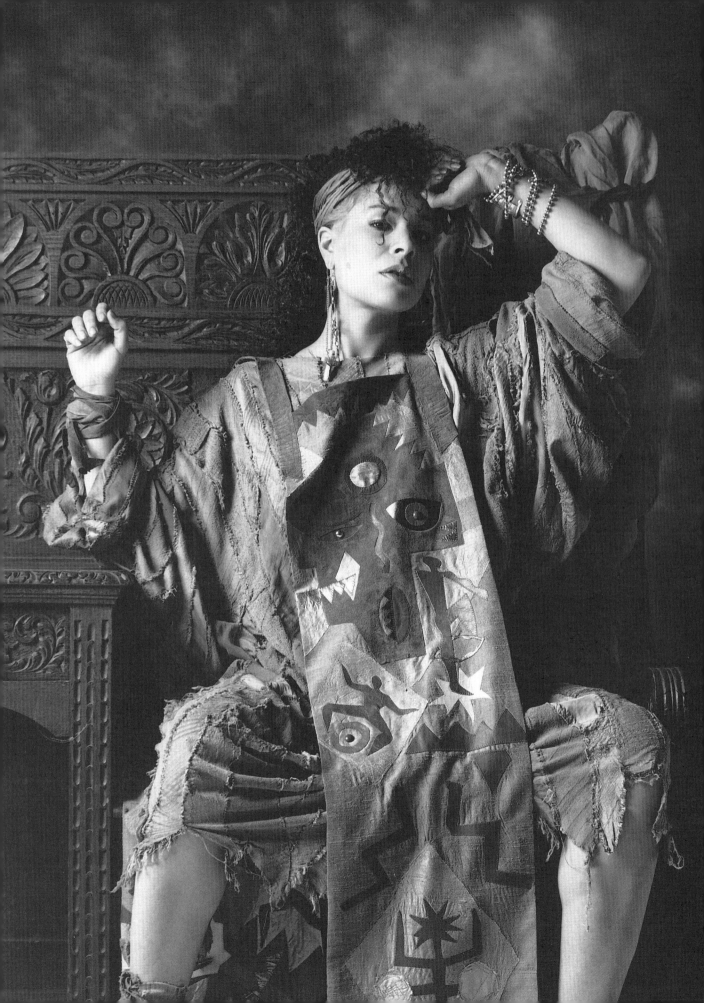

Diner, was rundown, raw, and cheap. The windows looked out on an exhaust pipe spewing heavy fumes over the derelict lanes and tenements immediately around them. Beyond, the Empire State Building, icon of industry, wealth, and confidence, reared up like a titan.

The mainly Hispanic neighbourhood had recently been discovered by artists because rents were low, but Andy's eighteen-thousand-dollar grant, greatly devalued by the U.S. exchange rate, didn't go far, and they were soon working at odd jobs to supplement their income. They airbrushed architectural drawings for Wal-mart, did renovation work, painting, and drywalling. New York, then as now, was full of aspiring artists. Tim's younger sister, Marthe, a fibre artist and writer, had lived in New York for some time with her husband, Tom Slaughter, a painter, and Tim and Andy's old friend. Close and mutually affectionate as children, Marthe and Tim grew closer in New York. In a supportive, energizing environment, on the ascendancy of his creative life, Tim's move to Manhattan could have brought about his breakthrough to international prominence. Unfortunately, however, he was never able to take the city on seriously. Exhibition opportunities in New York just didn't materialize as frequently as he had hoped. And ironically, having arrived in New York with impressive credentials and a growing reputation, he found his attention almost immediately diverted by new demands from an unexpected quarter. He received a commission from the organizers of Expo 86, the World's Fair in Vancouver, for a very large central space in the Canada Pavilion, which soon required all his energy. Although he was able

to complete some preparatory work for the project in New York and attempted to continue its development from there, complications and details regarding the complex construction required him to travel to Toronto frequently, and personally oversee material considerations and the mechanical movement for the piece.

Fabo remained in New York. A young figurative painter, he faced the difficult task of trying to break in to a fast-paced market already glutted and beginning to tire of figurative painters. The Canada Council had supposed no doubt that he, an energetic and enterprising artist, would benefit and eventually capitalize on the creative ferment of the city. But the timing was bad. His wave had passed through New York sometime before. There were hardly any exhibitions. The City of the Red Night, always voracious, can also be curiously indifferent. Many artists hang on for years, toiling in obscurity as cabbies or waiters, sitting by the phone, afraid to leave even for a weekend in case the call from a gallery should come. "You have to know when to leave,"[17] Andy says. He stayed on in New York until early 1986, then rejoined Tim in Toronto.

Working out of a studio on Roncesvalles Avenue in west-end Toronto, Tim meanwhile was deeply absorbed in his latest project. The piece for Expo 86 was one of seven artworks commissioned for the Great Hall of the Canada Pavilion, whose theme, national icons inspired by folk art, had drawn proposals from around the country. Pavilion designer Norman Hay hired Peter Day to select the winning entrants: Patrick Amiot, Richard Prince, Katherine McLean, John Watts, Edward Poitras, Beau Dick, and Tim Jocelyn. Tim's piece, a monumental motorized construction of four rotating concentric disks fifteen feet in diameter, was titled *New Dimensions Astrolabe*. He confined himself to the primary colours, used small amounts of white and black with complex restraint, to compose the four elements on

the sides of each disk. Flat expanses of yellow and red stood for Earth and Fire on one side, blue, from deepest navy to pale aquamarine, for Water and Air on the other. To the surfaces of each rotating disk he affixed animals, birds, and fishes wonderfully drawn with knife and scissors like colourform plastic decals, then scattered lightning bolts, comets, and satellites in the spaces between them like a magician's book of spells. The official Canadian images, beavers, moose, and geese, are beautiful, important, heavy, gentle, and pure, their national vernacular both appealing and lighthearted. They are secondary, however, to the meaning of the work, for the entire apparatus revolves majestically to the cadence of a carefully sequenced order, brilliantly and painstakingly computer-programmed by Bruce Cummer, and the rims of the astrolabe are divided, counted out, and incised, inviting comparisons with older synchronic protocols: astronomy, chronometry, and other more obscure and arcane sciences.

Tim knew that the ancients used the astrolabe, humanity's oldest scientific instrument, to observe the positions and attitudes of celestial bodies. Medieval seafarers determined latitude by sighting along tables of the sun's declination inscribed along an astrolabe's rim. They used the rete, a web-like plate etched with a map of the stars and the circle of the zodiac on its reverse side, to tell the time of day. An earlier astronomical device, the armillary sphere, from which the astrolabe evolved, represented the great circles of the heavens. Later, the planisphere attempted a flat representation of the sky, showing the movements of the planets and the fixed positions of the constellations on a series of concentric disks. Tim's *New Dimensions Astrolabe* combines and extends all of these ideas to form a densely inscribed mythological instrument and the descendant of an ancient and specific cosmological model. For, long before the Renaissance, the alchemists devised the *mappemonde*, a spherical representation of the

world on a disk's surface, used to illustrate concepts more philosophical than geographical. To the Gnostics who read it, the *mappemonde* depicted the perceptible universe as an elaborate mechanical cage which imprisoned the divine soul of man.[18] What then must we make of Tim's *New Dimensions Astrolabe* but that it represents both a path and an instrument of liberation from the bonds of this material world? It is a dial, a multilayered clock, a prismatic division of the sun's ecliptic into the four elements of matter. It is a system, a signpost for a new geography, and a threshold to a new dimension somewhere else. A dramatic, flickering screen. The massive piece seemed to put enormous strain on Tim's energy and strength. By February 1986, when the promotional photographs for the *New Dimensions Astrolabe* were shot, it was evident that he was sick.

He told us in March. It was HIV, precursor to AIDS. The Orwellian plague. A kind of cancer, a kind of radiation sickness, a kind of psychosomatic response to the invasion of the body snatchers. "I'm in trouble," he said. He'd said that before, but this time it was with an intimacy which collapsed the renown gathered around him like a drifting-down fume of parachute silk. AIDS was a rumour, a science fiction we didn't believe until we saw it eat voraciously through him. With astonishing, appalling rapidity he lost weight. He lost colour, then strength, becoming feeble and unsteady in a matter of months. Hospital admissions for a few days stretched out into month-long stays, while a procession of friends and road companions made their way to his side. He was trying to work from his hospital bed on a new series of cutout images when he lost his sight. Kaposi's sarcoma turned his skin into a dry, flailed tenderness; his limbs long and fine-boned, concentrated and still, lay under the sheets. "Bring me hot and sour soup," he said in September. "Bring me strawberries." But after one

small mouthful, leaning upright in the white-sheeted bed, he spit it out in his hand, looking up apologetically. Light sky-blue eyes. "I thought I could," he said.

Nothing.

Nothing was the same.

It was December when he died, 1986. By then the sickness had transfigured his face into a tidal pool of drifting, animated and violent silence. He died in his father's apartment in Rosedale Valley, his family and closest friends beside him, borne out of this world on the belly yell of disbelief and mourning which issued from the hundreds of people who loved him.

Things didn't end. One still can see, fifteen years later, Tim's joyful visual inflection, in signage, banners, and clothing here in Toronto and New York, though the dark enigmatic imagery of his last work is startling now. He clothed it well in gorgeous, uncanny colours, smoothing against its body the finest of his cloths, drawing taut and perfect the best of his treasures across its broad face.

The deep unquiet vision behind the screen.

NOTES

1. Letter to Krys Romaniuk, July 29, 1971, Skiathos, Greece.
2. Letter to Krys Romaniuk, June 15, 1971, Skiathos, Greece.
3. Letter to Krys Romaniuk, October 22, 1971, Kathmandu, Nepal.
4. Noah James, "Fashion Doubles as Art Form," *Globe and Mail*, June 30, 1981.
5. Christina Downs, Montreal *Gazette*, November 26, 1981.
6. Sybil Goldstein, interview with the author, February 22, 2001.
7. Oliver Girling, quoted in Ursula Pflug, "Co-op Studio Opens on Spadina," *Now* magazine, September 1981.
8. See Christopher Hume's characterization of ChromaZone as a gang of angry young men in his "Off the Wall" column, "More Than the Eye Immediately Sees," *Sunday Star*, February 21, 1982.
9. ChromaZone press release.
10. Marilyn Morley, "Imagination, Wearable Art Gets Send-up in Zany Show," *Toronto Sun*, December 17, 1981.
11. John Bentley Mays, "Chromaliving Proves Traditions Are Dead," *Globe and Mail*, October 22, 1983.
12. Marilyn Morley, "Chromaliving Exhibit Homes In With Humour," *Toronto Sun*, November 13, 1981.
13. Andy Fabo, interview with the author, February 28, 2001.
14. David Livingstone, "Designing in Rags," *Globe and Mail*, December 6, 1983.
15. Livingstone, "Designing in Rags."
16. Doug Brooker, videotaped interview with Sybil Goldstein, 1996.
17. Andy Fabo, interview with the author, February 28, 2001.
18. *Encyclopaedia Britannica*, 15th ed., "Astronomical Maps."

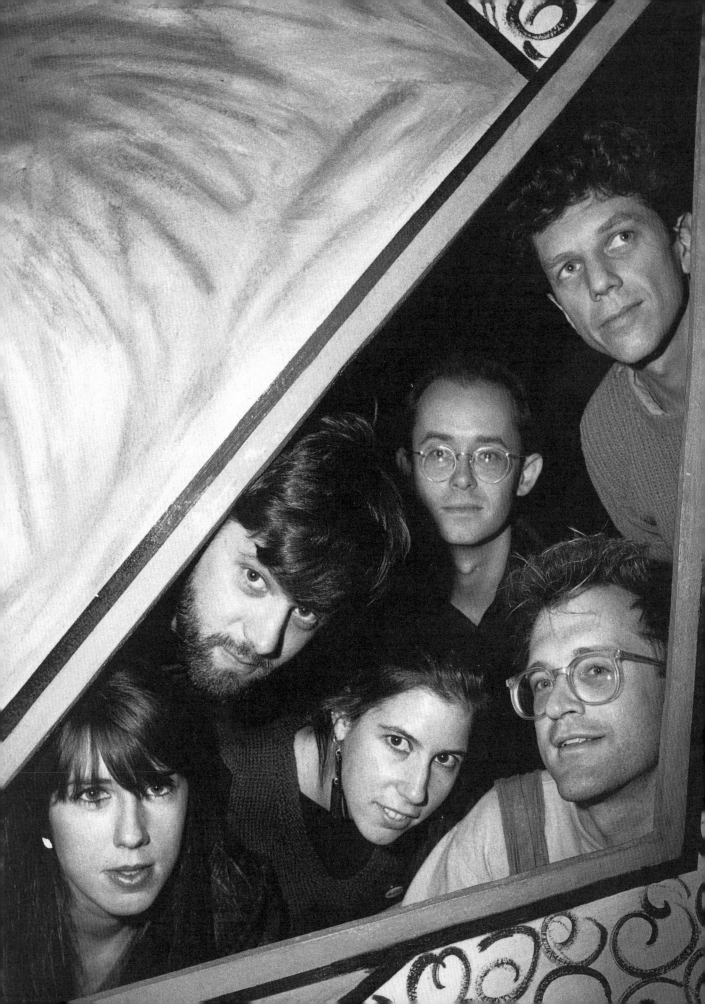

CHROMALIVING: The Wedding of Art and Life

DONNA LYPCHUK

November 3, 1983. Painting was dead and Apollo was my god. Art was the dead body lying on the table and critics and curators were the coroners, carrying the work into the parallel galleries and writing up the autopsy.

This cool, rainy evening, I was on my way to the site of the former Harridges department store to see what was being loosely referred to as "the artist's shopping mall." I ascended the escalator to the second floor of the Colonnade at 131 Bloor Street West expecting to see some jewellery, maybe some nice embroidered scarves, a couple of amusing knick-knacks, and, if I was lucky, a nice, imaginary dead theoretical body I could dissect for some periodical for about one hundred bucks. Instead, at the top of the automatic stairway I was confronted by Apollo's ideological nemesis – Dionysus. Yes. Not only was Dionysus, the god of vitality, joy, lust, enthusiasm, performance, delight, pleasure, and, yes, *fashion*, alive and well and kicking and bouncing off the walls, but he was pissed, in both senses of the word. Mad with revenge and drunk with glory, Dionysus was conducting a bizarre, taboo aesthetic orgy in this space called *Chromaliving*. The midwife of this naked, bawling burst of expression of life? An unassuming, pleasant, and mild-mannered fashion-designer-cum-part-time-miracle-worker named Tim Jocelyn.

A riot of colour desecrated every inch of this formerly respectable consumer mecca, now strewn with every imaginable perversion of familiar and everyday objects. Chairs that morphed into doors arched over the crowd's heads and lawn chairs made of polka-dot vinyl beckoned one to sit a spell beneath chandeliers made of real birdcages. Mannequins outfitted in venetian blinds and pelts of unknown animals summoned the visitor towards

Opposite: Chromaliving *group portrait, 1983: bottom, from left, Elinor Rose Galbraith, Carla Garnet, Tim Jocelyn; top, from left, Andy Fabo, Chris Radigan, Marty Kohn*
Photo: Susan King
Courtesy Tim Jocelyn Art Foundation

a series of closet-size rooms, filled with surprises. Lamps snaked up walls, and post–Russian constructivist figures tracked like little soldiers across the sinuous archways. The arches (not the soldiers) were an original and unattractive architectural feature of this oh-so-seventies space.

A labyrinth took you past the archway emblazoned with the sombre socialist command "WORK TO RULE" and through showcases of peep shows, architectural models, fountains of wasted youth, mutant televisions, neo-primitive apartments, confessional booths, crematoria, fall-out shelters, meditation meccas, and a series of living rooms and dwelling spaces that seemed more suitable for occupation by aliens than humans. Former changing rooms were transformed into boudoirs, death chambers, interrogation rooms, and dens of iniquity. And oh! horror of horrors, especially to an Apollonian art critic, installations seemed to bleed and merge into one other. It was as if the collective consciousness that created this was hell-bent on desecrating everything that was hateful about curatorial practice.

This unusual artist-curated exhibition also turned the tables on the whole idea of consumerism. It ingested you. And if you were a critic or a curator at the time, it bit you: it chewed you up and sent you on your way with a pat on the bum that said, "Your job is obsolete now." I shared this impression with critic John Bentley Mays, who wrote in the *Globe and Mail* that "*Chromaliving* is not so much a gathering of objects as an object itself – a curious sprawling organism composed of an enormous number of paintings, sculptures, drawings, murals, installations, chairs and tables, objets de virtu, objets d'art, fountains, vases, rugs and things that go bump in the night."

It was hard not to bump into someone that night, as the place was filled with milling art stars, art tarts, and celebrities busy gazing at the exotic creatures parading down the centre of the space, their hair sticking straight up as if fresh from a

session in the electric chair. The fashion highlights included a wooden bikini by Tanya Mars, a Mactac wedding dress knock-off of the recently married Princess of Wales by filmmaker Frances Leeming, and Ron Balicki's Eiffel Tower hat.

This now-legendary exhibition, which ChromaZone co-founder Rae Johnson describes as "the spontaneous amplification of Queen Street energy," was way ahead of its time. It identified cross-cultural, cross-disciplinary, and cross-gender movements that had yet to infiltrate the public or parallel art-gallery systems. It provoked all kinds of questions about commodification and art, and art's relationship to lifestyle. Oddly pragmatic, it proved to the world that you didn't need money, curators, bureaucracy, and sanctions by the high priests of Apollo to, as Johnson puts it, "do stuff." *Chromaliving* generated what exhibition administrator Carla Garnet describes as "a collegial fun atmosphere. . . . At the time, the art world could literally be compared to a corpse. *Chromaliving* brought Canadian art back to life."

The culprits behind this spontaneous comeback were the members of the notorious ChromaZone art collective and its enthusiastic guest curator Tim Jocelyn. ChromaZone was born at the tail end of what member Andy Fabo calls the "early conceptual era" of Canadian art, in which installation dominated the curatorial content of the parallel art-gallery system and colour field painting was the main commodity in commercial art. Figurative painting was a ten-letter swear word that did not belong in the sophisticated and often confusing lexicon of "smart art." Art was also suffering from a serious but spiritually mature case of Zen-like detachment from the concept of pleasure. The art-gallery experience at that time could be described as Presbyterian: one joined an exclusive group in a space as silent and sterile as a marble mortuary and pretended to enjoy the monotony of a long eulogy. I use this analogy to

illustrate the hullabaloo that *Chromaliving* caused at the time. It was like holding a rave in the middle of a church service.

ChromaZone was formed in 1981 by figurative painters Andy Fabo, Oliver Girling, Sybil Goldstein, Rae Johnson, Hans-Peter Marti, Tony Wilson (and for a brief while Brian Burnett and Stephen Niblock) as a kind of allergic reaction to the Apollonian pollen floating in the art-world air. According to Oliver Girling, *Chromaliving* was the result of "invention being the mother of necessity." The gallery's home was in Girling's space at 320 Spadina Avenue, which, as kismet would have it, just happened to be the former residence of another famous shit-disturber – social activist Emma Goldman. For the next two years, ChromaZone defiantly enforced their unusual mandate: to show figurative painting, practise inclusivity, be artist-supported, and above all be spontaneous, alive, and fun.

When asked how *Chromaliving* came to be, those involved unanimously describe it as "a product of love." The idea was the brainchild of Fabo and Jocelyn. According to Fabo, both were influenced by the artists of the twenties: "We were really into the symbolism of the Russian secessionists. Klimt was a factor . . . , Kandinsky, and in particular the work of Sonia Delaunay, who was famous for transferring cubist designs onto fabric. We were responding to an eighties revival in her work and in the work of Papova Schenko in the fabric industry. We were basically paying tribute to visual things that we loved."

Fabo, Girling, Goldstein, and Johnson state that Edvard Munch was an influence on each of their styles, as well as on the work of local painters such as Michael Merrill and Brian Burnett. Munch was a kind of electrical current that was running through their approach to brushwork. This theme was so prevalent that it was almost a joke to the collective's insiders. As they sat around trying to think up an

idea for the poster, Goldstein said, "Whatever you do, don't make it like *The Scream*." She looked over Fabo's shoulder to see him doodling a redo of the familiar image that would later become *Chromaliving*'s poster and logo.

Jocelyn's main intent as a curator was to "show that the traditional boundaries between arts and crafts are breaking down."[1] In 1981, Tim took part in a fashion show at the Theatre Centre called *Jaywalking the Intersection of Fashion and Art* that featured the offbeat designs of David Buchan, Tanya Mars, Aileen Beninger, and Annie Nikolajevich. These designs, which included a codpiece made from a Campbell's tomato soup can and an outfit constructed from a neon skipping rope, started the gears clicking in Jocelyn's head. "Tim made the collective aware there was a crossover between art and lifestyle taking place that was reminiscent of the William Morris Arts and Crafts movement."[2]

The core idea was to create a parody of the Canadian National Exhibition's annual Home Show: "The intention was to blur the distinctions between fine and applied art."[3] The exhibition's initial press release refined this further: "*Chromaliving* addresses a burst of energy in the Toronto art scene similar to Paris in the twenties, New York and London in the fifties and Kathmandu in 1972 – it employs non-traditional media and formats experimenting with every form of applied art. It smudges the boundaries between art and functionality usually thought to be expressive of decadence." To give you an idea of the attitude towards such "decadence," which by today's jaded standards seems pretty squeaky clean, one critic described the result "as 150 homegrown Toronto artists who are usually tucked away like dangerous animals in the basement of our subculture."[4] A critic in the usually progressive *The Body Politic* questioned the point at all of "transforming everyday furnishing and fixtures so that they lose any sense of their placement in the real world."[5]

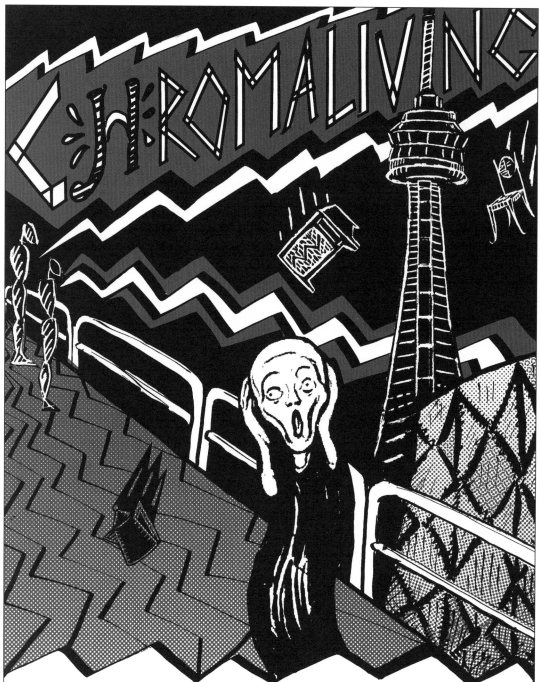

ChromaZone presents **CHROMALIVING**
the Colonnade, 131 Bloor St. W. (entrance through the mall 2nd Floor)

ROOMS AND FURNITURE BY 100 ARTISTS

OCTOBER 19 — NOVEMBER 12, 1983

Tuesday, Wednesday & Saturday 11 AM to 6 PM
Thursday and Friday 11 AM to 10 PM General Admission $1.00

GALA VERNISSAGE —$5.00 . . .Oct. 19, 1983 6 PM to 10 PM

Supported by the Ontario Arts Council and the Canada Council.

In retrospect, it is seems both typically mean-spirited and somewhat backward to refer to *Chromaliving* as being a subcultural influence. The members of the ChromaZone collective were merely savvy to what was going on in the rest of the art world and had a philanthropic urge to bring Hogtown's stalled art scene up to speed on the latest developments. Both Fabo and Girling mention the artist-generated *Times Square Show*, which took place in New York the year before, as a major inspiration to Jocelyn. That show also addressed the issue of the "curator versus the impresario." Jocelyn, who was fascinated by the work of Matisse, could see the famous artist's legacy evolving in the work of the then little-known SAMO (a.k.a. Jean-Michel Basquiat) and the simple, radioactive-inspired designs of a young Keith Haring. Fabo also describes how at the time Tim and he thought it very important that they use Tim's connections in the fashion world to give Toronto its first look at Memphis design. "It has always been part of the ChromaZone idea to bring art to the public," says Fabo. "A show about alternatives, furniture, clothing, and living space fits right into that idea."[6]

One of the things that delighted Fabo about this exhibition was "its slipperiness. No sooner did you wrestle it down to elicit an explanation of what kind of beast it was, and it popped out of your arms, transformed into an organism of a different ilk."[7] It took a special beast-meister to tame this slippery monster, which roared with contradictions: funk clashed with elegance, the modern competed with the postmodern, and surrealism insulted realism. "Tim was really one to roll with the bugs," recalls Girling. Due to its spontaneous nature, it seemed that every time the show was completely defined, it managed to grow another head, like a multiplying hydra. "The pressure was enough to make a normal person explode," remembers Goldstein. "The man was the very model of invention."

Jocelyn's personality was almost alchemical in nature: a rare blend of patience, accommodation, generosity, discipline, logistical genius, optimism, energy, and grace under pressure. In Jocelyn's world, which fit in well with ChromaZone's attitude of inclusivity, "there was always room at the inn for one more." Always room for one more idea, one more artist, one more incredible and daring leap of faith. According to Johnson, "Tim was one of those people who could get anybody to do anything. . . . They just liked him so much they would gladly do anything for free." Fabo also credits the success of the show to Tim's positive attitude. "Tim really believed that if you were good to people, you could change the world."

Jocelyn used his connections in the fashion, film, and art worlds to enlist an army of friends to help him realize his vision. Art critic Jennifer Oille and art dealers Fela Grünwald and Evelyn Amis aided Tim in his goal to insinuate an artistic presence into the carriage trade. It was Amis who encouraged Max Goldhar, the president of Revenue Properties, to donate the ten-thousand-square-foot space to house the project.

Architect Marty Kohn recalls his excitement when he was asked to "turn this old frock shop into something fabulous. I was very flattered to be able to help out. Tim's attitude reminded me of the kind of thing you'd see in an old Mickey Rooney–Judy Garland movie – Hey, kids, I've got a barn. Why don't we put on a show?"

Kohn, along with fellow architect Chris Radigan and construction coordinator Elinor Rose Galbraith, had exactly three weeks to transform the empty space into an exhibition hall. The challenge for

Opposite: Chromaliving *poster, offset, 18" x 12", 1983, design by Andy Fabo*
Courtesy ChromaZone, Toronto

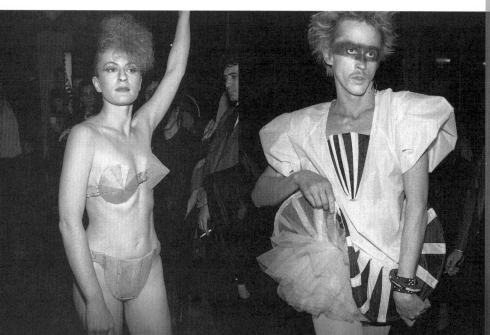

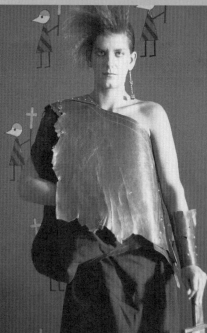

1. Tim Jocelyn and Randy Gledhill on opening night, October 1983
Photo: David Hlynsky
2. Elizabeth Chitty modelling Wooden Bikini by Tanya Mars
Photo: Susan King
3. Niel Gordon modelling Kinetic Dress by Aileen Beninger
Photo: Susan King
Courtesy Susan King, Toronto
4. Shannon McConnell modelling Urban Tribal Garb by Denis Joffre,
in front of Queen Street Mural by Mark Harman
Photo: Tony Wilson
5. Judy Holme modelling Sirens of Saturn by Jamie Hart, in front of
Night Light Tunnel Vision by Dyan Marie

Photos courtesy Tim Jocelyn Art Foundation

Kohn was "to create a passageway from one end to other using sheets of corrugated fibreglass. CIL donated ten cans of paint in different colours, and I remember Elinor opening can after can. It was always a surprise, as we never knew what colour would be inside. Tim was the one who designated the colours to floors and walls."

Carla Garnet, who had been administering the project for the previous three months in the relative peace of an office at the Cameron Hotel, describes the madness that occurred during the days leading up to the exhibition. As she told me this story, I pictured her with her hands clapped against her cheeks like the subject of *The Scream*. "The exhibition received a grant for six thousand dollars originally designated for seventy-five artists. In the last three days, the word got out and the artists just started to show up, slides in hand. If Andy and Tim thought they had chutzpah, they would just let them in. I was tearing my hair out trying to process all of this information. In the end, the place was crawling with 150 people, not including the fashion models, hairdressers, makeup artists, emcees, and musicians. It was all worth it. Opening night was truly one of the great moments of light in Queen Street art history."

Chromaliving was one of the few exhibitions in Canadian history that was curated in such a spontaneous and organic way. Its conception was very Hegelian, in that it allowed ideas to spiral out of other ideas and branch into concepts both sympathetic and contrary to the show's mandate. It could be compared to a wildflower garden: the idea was thrown up in the air and cross-pollinated by what was in the wind. The result was an unruly, exotic Eden of visual delights that was not subject to any weeding or pesticidal treatment from the curators.

It also functioned as a rare snapshot of the adolescent Queen Street art scene's emergent themes. In an exhibition that included over 150 artists, the author of this article would like to be forgiven for any sins of omission she may commit in the next few paragraphs.

At one end of the *Chromaliving* spectrum of work, there was the painterly theme of *The Scream*, which seemed to shimmer through the visual works in the show like an electric current. *Chromaliving*'s major accomplishment was that it took non-figurative painting out of the studio and put it back in the gallery. This style resonated through the imagery that recurred on murals, screens, fabric, and on light panels. It echoed in the skull-like faces of John Scott and Elinor Rose Galbraith's *Bunny Boudoir*, and in the writhing, sensuous embrace depicted on Andy Fabo's plaster mural. *The Scream* reverberated in the tremulous lines of Brian Burnett's portraits of urinals and toilets and Johnson's frightening reconstruction of an artist's studio which featured a hollow wire dummy. This installation brought more than just painting back into the gallery – it brought the entire painter's studio, complete with paints, messy tables, coffee cups, and ashtrays.

Visual references to the Russian constructivists and the secessionists gave the exhibition a socialist, irreverent, and rebellious air. Tony Wilson's impressive *Work to Rule Archway*, considered to be a masterpiece by many, was buttressed by two decorative larger-than-life nudes that parodied communist themes. Michael Merrill's stark black-and-white installation *Archimedes Bath* featured a rude nude and shocking image that mocked the style into a cartoon. Mauro Iacobelli's painted screen *Broadwalk* featured three panels of semi-cubist muscle-bound creatures that seemed to wrestle within the confines of their design. Mark Harman's *Queen Street Mural* presented yet another take on this style: in retrospect, his charming little symbolist figures, created from circles and triangles and neon crosses, seem oddly predictive of the later work of Keith Haring.

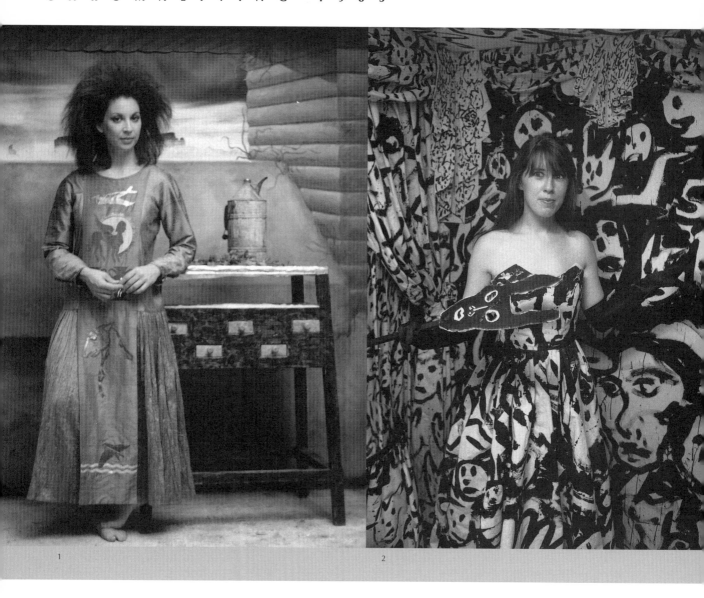

1. *Sybil Goldstein modelling* Florentine Dress *by
Tim Jocelyn; Mural by Jak Oliver; Table;* Love Philters
by David Moore
Photo: Tony Wilson
Courtesy Sybil Goldstein, Toronto
2. *Elinor Rose Galbraith in the* Bunny Boudoir *by
John Scott and Elinor Rose Galbraith*
Photo: Susan King
Courtesy Tim Jocelyn Art Foundation

The theme of Russian constructivism wedded nicely to the theme of neo-primitivism that also characterized the "look" of *Chromaliving*. This look, pioneered by Tim, was reflected in the appliqués that adorned his *Post-Metropolis Screen*. This wedded style was evident on everything from Helen Cloney's *Twister Misters* ceramic ashtrays, which featured glazed images of dancing teenagers, to the nude musclemen replicated on the base of the iron on Roman Balicki's *Homo-iron*. Less formal was Alan Glicksman's *Archway*, which featured a series of glyphs depicting bees, cats, and slaves that were semi-Egyptian and semi-Native American in flavour.

Art consisting of post-apocalyptic scenarios, pornography, and allusions to a living hell provided a humorous ironic counterpoint to the whole idea of "lifestyle." Some of these creations alluded, in a kitsch and gloomy way, to Cold War visual affectations. Doug Walker's shattered *New World Artifact* was a blender reconstructed for the purposes of display in a post-apocalyptic home that would worship objects from a more plentiful past. Carolyn White's *Critical Chair* was a black, coffin-like construction illuminated by a single light bulb in a room that resembled a KGB interrogation chamber.

Many of the artists created environments that mimicked different states of historical and psychological consciousness. Eldon Garnet's *You Can Lead a Horse to Water but You Can't Make It Drink*, a spare-looking arrangement of a chair, television set, and vase, captured the very essence of modern isolation. The FASTWÜRMS constructed a bizarre funeral pyre strewn with bones called *Father Brébeuf's Fugue State*. Rebecca Baird's installation *En el centro, si Dieta el cielo* was a meditation on her Indian ancestry that included the now-famous *Rice Krispy Cactus*. Joanne Todd and Sybil Goldstein chose to showcase their paintings in installations by other artists that parodied the set-up of traditional dining room and living room.

At the other end of the *Chromaliving* spectrum, artists experimented with the idea of pure design. There were many curios, novelties, and leaps of faith in the show, such as John Abrams's *Self Portrait* on a Persian rug, Barbara Klunder's scarf-like floor mat, and Peter Gray's *Astroturf Coffee Table*; but there were also contributions that are now considered to be classics of the genre, such as Robert Bowers's menacing symmetrical benches and Edward Fortune's column light fixtures. In some ways, the backbone of the show was provided by a group of older, more established artists who decided to come out and play, such as John MacGregor, a prominent Toronto painter, Loris Calzolari, a Memphis design veteran who displayed his famous *Comet Chair*, and the innovative Michael Robertson, who gave us an early glimpse of his asymmetrical clocks and neo-constructivist mobile recliner. Evan Penny leaped into the fray by contributing an institutional chair covered with patent leather and *Janet*, one of his lifelike nude sculptures. Department-store mannequins modelled General Idea's *Venetian Blinds* dresses – "a celebration of the contradictions of seeing art as merchandise."[8]

Chromaliving encouraged some artists to experiment in different media. Prominent photographer Jayce Salloum did a neo-primitive painting, while neo-primitive painter Richard Banks immortalized his dog's pawprints in cement. Art critic and curator Ihor Holubizky contributed an etched granite placemat. Musician/entrepreneur Robert Stewart and his girlfriend Sue Young created a crowd-pleasing installation, the *Toxic Peep Show*, which featured toy view-finders embedded into the walls.

Video art and performance art were important components of the exhibition. The constantly running videos, by seminal artists such as Andy Paterson, Vera Frankel, Paulette Phillips, Christian Morrison, and Randy and Berenicci, added an eerie flickering element to the post-apocalyptic,

neo-pagan feel of the space. *Chromaliving* was also probably the only art show in Canadian history that was routinely cleaned by its own live-in maid – the fascinating performance artist David Roche, who dressed up as a female servant and regularly entertained crowds with his perverse tales about cleaning rich people's houses.

The show also presented numerous interesting instances of collaboration. One of the main co-conspirators was Natalie Olanick, who collaborated on a wall mural with Oliver Girling as well as a dress constructed from an Andy Fabo canvas. John Scott and Elinor Rose Galbraith pulled off a fashion coup called *The Bunny Boudoir*, which featured a dressing room and a dress that was painted, stitched together, and created right on the spot on opening night in front of the eyes of an awestruck crowd.

The exhibition was accompanied by a fashion show that featured prominent Queen Street society ladies such as Molly Johnson, Adele Steinberg, and Susan Walker wearing the post-constructivist designs of Roman Balicki, Aileen Beninger, Susan Dickson, Tanya Mars, Jamie D. Hart, and several others. The wacky clothing and asymmetrical hair designs by John Steinberg reiterated the themes expressed in the visual art. Molly Johnson sported a hat by Jamie D. Hart that resembled an atomic-age satellite dish. Susan Clark sported a *Kinetic Dress* by Aileen Beninger that made her look like a relief figure that had just walked off the wall of the Toronto Stock Exchange. Shannon McConnell wore a *Reptile Tunic* constructed out of hundreds of leather medallion coins that got the press spreading rumours that there was new urban female warrior in town long before Tank Girl's arrival. Jennifer Oille modelled a glamorous beaded creation by Lee Dickson, and Sybil Goldstein presented the revisionist *Florentine Dress* by Tim Jocelyn. Performance artist William Brown bounced around onstage as the planet earth and also stood outside on the street in his orb-like getup handing out buttons with a question mark on them.

Indeed, that night it did feel at least briefly as if the artists were on top of the world. Sybil Goldstein describes it as "a great cross-cultural collaborative moment that marked the beginning of a two-to-five-year cycle." Like a stone dropped in a pond, the show had a kind of ripple effect. The demand for similar events inspired Molly Johnson to open the Art Bar. Carla Garnet, a former artist who also exhibited a glass screen in the show, became addicted to full-time crisis management and started her own art gallery, Garnet Press. The artists' co-operative Cold City was created soon after *Chromaliving*'s big splash in the art world, and successfully adopted ChromaZone's mandate of inclusivity and self-funding. According to Esther Shipman, the executive director of Virtu: "*Chromaliving* was the impetus that persuaded Harbourfront to start showing furniture designed by artists. The popularity of the show persuaded us that there was a demand to see this stuff by the public." The exhibition was also something of a success commercially, as a writer from *Flare* magazine observed: "It was amazing to see how the exhibition brought out the shopper in the public" who loved to browse in the artist boutique. Art critic Nik Sheehan, who wrote the all-important *Now* cover story, has since remarked upon "the freedom and hedonism brought to the art world by incorporating cross-disciplinary and cross-gender elements." The official word from *Art Forum* was that the show represented "a drift back to old-fashioned studio practice." I like to refer to it as the night the pickle finally slid out of the art world's ass.

Chromaliving also achieved its goal of reaching as many people as possible. The exhibition, which by Marty Kohn's estimate may have been attended by as many as thirty-five thousand people, has inevitably had an effect on a whole generation of young artists.

Perhaps its biggest achievement was the creation of a new life, a new spirit that rejuvenated the Toronto art scene for some years afterwards.

As Tim Jocelyn wrote in his *C Magazine* article, "Settling Accounts," "Somewhere along the line it became evident that we were creating an astonishing environment and an artistic event unprecedented in Toronto. Artist after artist rose to the challenge of transformation as the construction and debris was cleared what emerged was a wildly diverse and weirdly harmonious organism. *Chromaliving* proves that there is a wealth of art – besides painting – that can be made in Toronto and that the renewed commitment to the art object takes on a multitude of different forms, from the crudely constructed to the finely crafted. Combining recent and older works, established artists with newcomers, clothing, furniture and ceramic designs with painting, sculpture, video, performance and installation the show revealed unexpected coincidences between these various elements. Ultimately, *Chromaliving* was about bringing art to life – and about what can happen when 150 artists occupy a department store."

NOTES

1. Tim Jocelyn, quoted in Christopher Hume, "Chromaliving Shows Art as Lifestyle," *Toronto Star*, October 22, 1983.
2. Carla Garnet, interview with the author, 2001.
3. Andy Fabo, quoted in Hume, "Chromaliving Shows Art as Lifestyle."
4. Marilyn Morley, "Chromaliving Exhibit Homes in with Humour," *Toronto Sun*, November 3, 1983.
5. David Vereschagin, "Life in the ChromaZone," *The Body Politic*, no. 99, December 1983.
6. Andy Fabo, quoted in Nik Sheehan, "ChromaZone's New Designs for Living," *NOW magazine*, November 3, 1983.
7. Andy Fabo, quoted in "Chromaliving . . . From Whence It Came . . . ," an essay in the *Chromaliving* exhibition catalogue.
8. Andy Fabo, quoted in Sheehan, "ChromaZone's New Designs for Living."

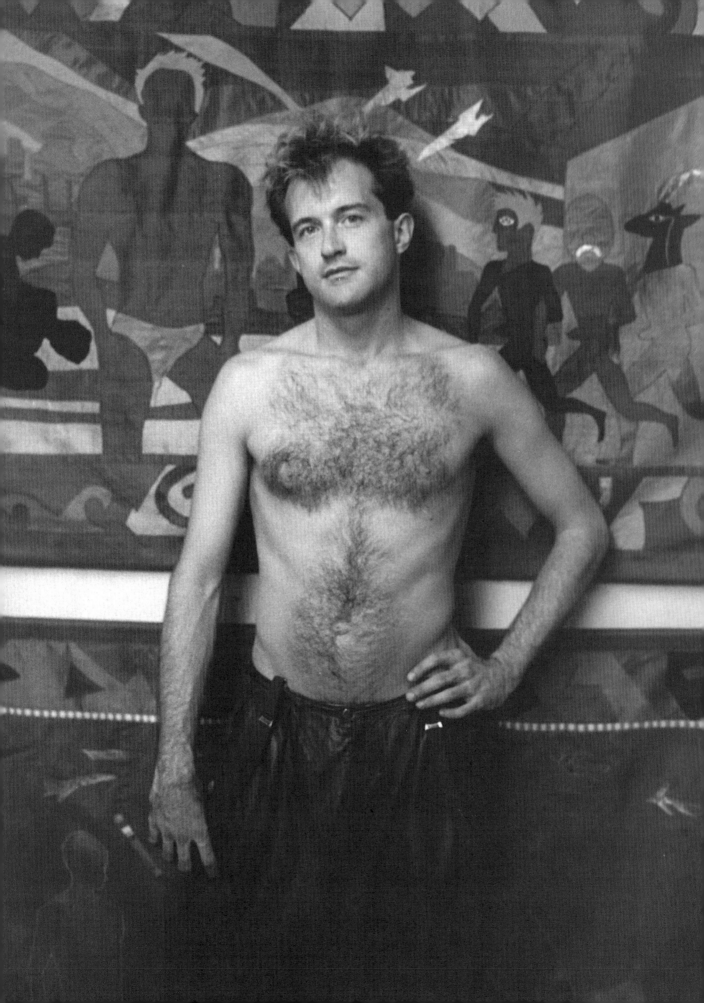

THE ASCENT OF ICARUS: On the Art of Tim Jocelyn

STUART REID

Tim Jocelyn combined the rigour of fine craft traditions with streetwise, cutting-edge visual art in the many fashionable garments, pieces of decorated furniture, textile banners, paper cutouts, and sculptural constructions he produced during his frenzied career. One might describe the energy running through his bold, colourful compositions as ecstatic. The word "ecstatic" comes from the Greek root *ekstasis*, which means, literally, to stand outside oneself. And indeed, this concept of transcending the physical self, of acting on impulses outside the individual's concerns, is in keeping with many aspects of Jocelyn's life and work.

Again and again, a study of Jocelyn's imagery reveals the archetypal story of Icarus, the fallen boy who, with manmade wings, flew too close to

the sun. In Jocelyn's brightly coloured four-panel screen called *Re-Signing Icarus* (1985, silk and leather, 65" x 64", Collection of the Macdonald Stewart Art Centre, Guelph), images of ascent are mingled both with tribal images of nature and geometric patterning that hints at the technological world. On the panel titled *Next Icarus*, an image of an astronaut's suit hovers in the blue sky adjacent to the grid of a satellite arm, reminding us that a present-day human, as a modern Icarus, can cheat the laws of nature and soar ever higher. Icarus appears as a winged figure, a hybrid incarnation that gives him dominion over the land and the air. Jocelyn incorporates images of newt-like amphibious creatures on the bottom third of the panel called *Beatification of Icarus*. These graphic shapes, cut and appliquéd from blue and black fabric, represent still other creatures that can move between worlds, in this case the land and the sea.

Jocelyn's *Re-Signing Icarus* screen unfolds in panels, inviting a narrative reading. As we read across, we see the central figure emerge from the

Opposite: Tim Jocelyn in front of Cities of the Red Night, *1984*
Photo: Tony Wilson
Courtesy Tim Jocelyn Art Foundation

sea to construct a tower on the land, then to climb into the air, and eventually to hover in outer space. The folding screen is an open-ended story that leaves room for other panels – unwritten prologues and further chapters to come.

It is inspiring to examine Jocelyn's short but productive career (he died in 1986 at the age of thirty-four). He was a prolific visionary, who deliberately transgressed any boundary set around him. He ignored, for instance, the traditional hierarchy governing the divisions between fine art, fashion, and craft. In his own work, and in his entrepreneurial activities as an organizer and promoter, no project was too big to be tackled and no attitude too entrenched to be challenged. Jocelyn lived on the stylish cusp of the art scene, constantly experimental in his work, maintaining close ties with his own creativity, defiant against attempts to categorize his production. He lived a joyful, transformative existence – like Icarus he moved effortlessly from one world to the next.

Jocelyn's dynamic surface decoration relied heavily on the technique of collage, the drawing together of bits of fabrics or colours that come from many sources. He developed an appreciation for material as a young man when he spent time in the Stratford Festival costume department – his father was head of the Festival orchestra. But it was after a trip to Turkey and Nepal in 1971 that Jocelyn became intrigued by the sophisticated textile arts he found there and began gathering pieces. He was particularly impressed by the *thankas*, Buddhist prayer banners that incorporated strips of brocades and other fabrics. Perhaps it was the coupling of beauty and meaning in the fabric of the *thankas* that was to inspire Jocelyn in his own work.

Jocelyn selected pieces of fabric for their colour and texture. They were then cut into shapes and composed into a design on a ground fabric, usually silk. The shapes were basted into place, then appliquéd. These panels, now much like paintings, were cut according to a garment pattern, and finally sewn into clothing. Jocelyn was able to create energy in his textile creations by contrasting shapes and colours on the charged, coloured grounds. The works brought disparate fragments of the artist's personal history into a new whole.

The artist began by making small "disco" purses, before quickly moving on to vests and, eventually, elaborately decorated jackets. Jocelyn was a painter before he taught himself the textile arts. In his early designs, he was influenced by Russian constructivist work from the twenties and the creations of Sonia Delaunay (1885-1979), a Russian expatriate who designed fabrics for the Italian fabric house of Bianchini Ferier. There are also references in his earlier designs to Wassily Kandinsky (1866-1944) and Henri Matisse (1869-1954), among others. The cutouts done by Matisse in the fifties reveal a fluid freedom and exuberant use of colour, harnessing purity by honing an evocative shape from solid colour, an impulse Jocelyn shared.

After a trip to New York City to see an exhibit of Mariano Fortuny's work at the Fashion Institute of Technology, Jocelyn became enamoured of the subdued colour schemes and symmetry implicit in Fortuny's garments. Jocelyn said, "With me the Fortuny influence is definitely important. I'm working with a very limited colour range – pewter, bronze, and greens. I'm looking at the influences of the classics, the Greek and medieval period. I've really begun to understand how something new can draw from the past."[1] It was after his exposure to the Fortuny tradition that Jocelyn's designs lost their linear quality and became softer, more flowing.

Jocelyn's exposure to the costume department at the Stratford Festival also led the artist to consider the performative aspect of costumes. Certain garments allude to ritual, to occasion, to role-playing, to authority, to aspects of sexuality. In each instance,

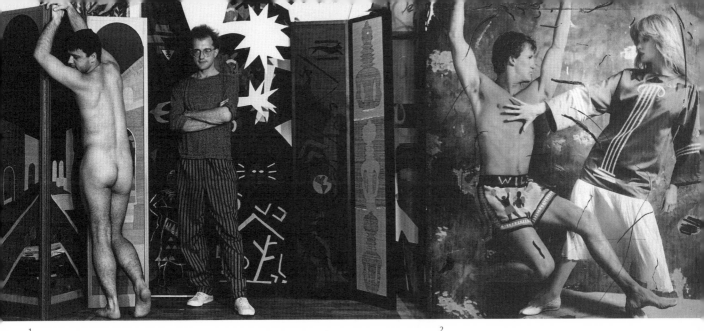

1

2

they transform the wearer. Such metamorphosis is clearly evident in Jocelyn's dress and jacket designs, which emblazon the wearer with dynamic swaths of colour that proclaim strength and self-assurance. The coupling of silk and leather appliqué makes for an erotic body covering. The unique designs, often inspired by other artists from the past, create a series of one-of-a-kind garments that reinforce the individuality of the wearer.

Other garments allude to historical eras in their formal appearance. Jocelyn's intricate imagery often encrypts messages and secrets in the garment. His *Florentine Dress* (1983, silk and leather, Collection of Macdonald Stewart Art Centre, Guelph), for example, endows the wearer with the power that accompanies the knowledge of its mysteries. A long red chasuble (a loose, sleeveless, usually ornate outer vestment worn by the celebrant of Mass or Eucharist in the Christian Church) is appliquéd with a stack of symbols that read like a modern hieroglyphic. An airplane, an amphora, a gryphon, a lion, a jumping dolphin, a cog from a wheel, two empty chairs, and a naked man rising in front of the sun – all are visible on the bib that hangs over a shimmering golden-green frock. The garment alludes to ceremony and plays ironically with the austerity of a religious

institution. At the same time, the shiny metallic silks give the dress a spiritual iridescence. Jocelyn was very conscious of the tactile quality of his fabrics. He said, "I just cut and build and try to be improvisational. I'm always aware of the light-reflective quality of fabrics. That's why I love the metallics. I've always worked with silk and increasingly, now, with leather. I love combining colour and textures."[2]

The combination of fabrics and scraps on the silk ground symbolized the cultural fusion at work in the art community that surrounded Jocelyn in Toronto in the eighties. Toronto (and Canada, for that matter) was increasingly fascinated by imagery from other cultures, at a time before the dialogue around cultural appropriation frowned on such exoticizing by a dominant culture. Jocelyn's textile works casually embodied antithetical aesthetics: his tribal motifs and stylized figures, for example, were reminiscent of African art, yet they also alluded strongly to the refinement of

1. Tim Jocelyn and Andy Fabo in Richmond Street studio, 1984
Photo: Tony Wilson
Courtesy Tim Jocelyn Art Foundation
2. Wild Boys Boxer Shorts *and* Ironic Column Dress, *1983*
Photo: George Whiteside
Courtesy Tim Jocelyn Art Foundation

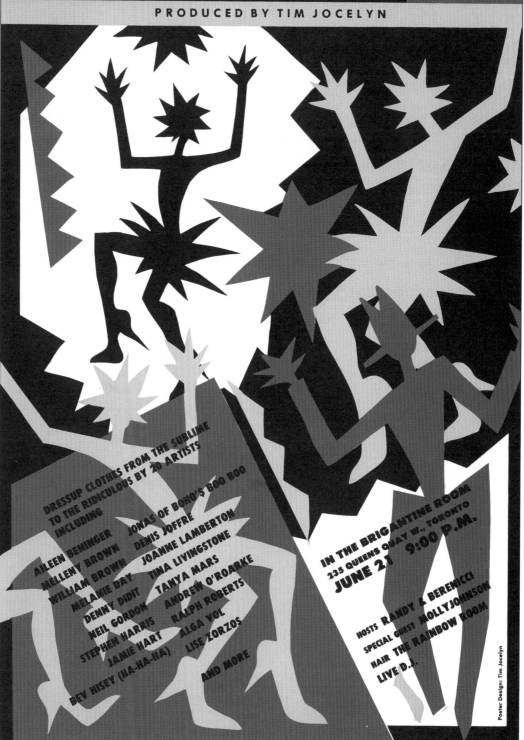

THE ART GALLERY AT HARBOURFRONT PRESENTS

DRESSING UP

PRODUCED BY TIM JOCELYN

DRESSUP CLOTHES FROM THE SUBLIME
TO THE RIDICULOUS BY 20 ARTISTS
INCLUDING

AILEEN BENINGER JONAS OF BOHO'S BOO BOO
MELLENY BROWN DENIS JOFFRE
WILLIAM BROWN JOANNE LAMBERTON
MELANIE DAY TINA LIVINGSTONE
DENNY DIDIT TANYA MARS
NEIL GORDON ANDREW O'ROARKE
STEPHEN HARRIS RALPH ROBERTS
JAMIE HART ALGA VOL
BEV HISEY (HA-HA-HA) LISE ZORZOS

AND MORE

IN THE BRIGANTINE ROOM
235 QUEENS QUAY W., TORONTO
JUNE 21 9:00 P.M.

HOSTS RANDY & BERENICCI
SPECIAL GUEST MOLLY JOHNSON
HAIR THE RAINBOW ROOM
LIVE D.J.

Poster Design: Tim Jocelyn

TICKETS $6.00 AVAILABLE AT HARBOURFRONT BOX OFFICE (869-8444) & ALL BASS OUTLETS.

Henri Matisse's elegant papercuts. Consider the term "sampling," which we now apply to the aural appropriations of recording artists: Jocelyn sampled other cultures, tried on different attitudes from various periods in art history, and created a new groove with an energy of its own.

Jocelyn was aware of and influenced by his New York–based contemporaries, Keith Haring (1958-1990) and Jean-Michel Basquiat (1960-1988), who drew their raw energy from the street and eventually brought the graffiti scrawl into the shrine of the contemporary museum. Like Haring and Basquiat, Jocelyn did not create his pieces for museum display. The work came from a calling in the immediate community, an appreciation for the energy that rippled through the urban youth movement.

Tim Jocelyn had the ability to step away from his own interests and, altruistically, involve the broader community of artists in events that he conceived. These important events, exhibitions, and happenings provided a nexus for a new energy and attitude in Toronto's visual-arts community. Jocelyn transgressed existing boundaries between working artists and the commercial and public gallery system by conceiving of an alternative forum that skirted the rules, attitudes, and pretenses of those institutions. Jocelyn belongs, as one of an important group of instigators, in any art historian's recounting of the maturation of the visual-arts scene in Toronto. It was a time when fashion fused the elements of life and art, art returned to the people and the streets. In his essay "The Snakes in the Garden," *Globe and Mail* art critic John Bentley Mays describes the limits faced by young artists in Toronto in the early eighties:

Opposite: Dressing Up *poster, offset, 11" x 17", 1984, design by Tim Jocelyn*
Courtesy Tim Jocelyn Art Foundation

There was also a new art scene, and the artists originally faced the same obstacles as their colleagues in other disciplines. Young artists tumbling out of the counterculture had virtually nowhere to go, if Avrom Isaacs, Carmen Lamanna, Dorothy Cameron and a few other perceptive and risk-taking dealers would not take them. And unlike the Vancouver Art Gallery, the Art Gallery of Ontario (except during the tenure there of Alvin Balkind) remained by and large aloof from the new developments in Toronto art, and willing to give only token acknowledgement to the changes overtaking art elsewhere in the world. So it happened that artists did what the dancers, writers and musicians also did, with equal and often surpassing success: they took matters into their own hands.[3]

This impulse again fuelled the proliferation of collectives and exhibitions in alternative spaces that defined the scene in the Toronto art world of the nineties.

Tim Jocelyn was associated and worked closely with the members of the ChromaZone collective, formed in 1981, in theory to reassert the importance of the art object amidst the rising interest in performance, video, and other time-oriented media. In 1981, he and Andy Fabo organized *Jaywalking the Intersection of Fashion and Art*, held at the Theatre Centre in Toronto. In conjunction with ChromaZone, Jocelyn was one of three organizers of *Chromaliving*, which was mounted in the former Harridges department store at the Colonnade at 131 Bloor Street West in Toronto from October 19 to November 12, 1983. Jocelyn, along with Andy Fabo and Carla Garnet, brought together objects, furniture, sculpture, and painting in installations that engaged art with everyday life and resulted in a watershed exhibition. Art was "not elevated and separate," Jocelyn said to John Bentley Mays.[4] Mays went on to say in his review of

D R E S S I N G U P 1 9 8 4

1. *Tanya Mars modelling* Pure Virtue *by
Tanya Mars and Elinor Rose Galbraith*
Photo: Anita Olanick
2. *Sharmayne Beddoe modelling* Hockey Bride
by Tina Livingston
Photo: Tony Wilson

1

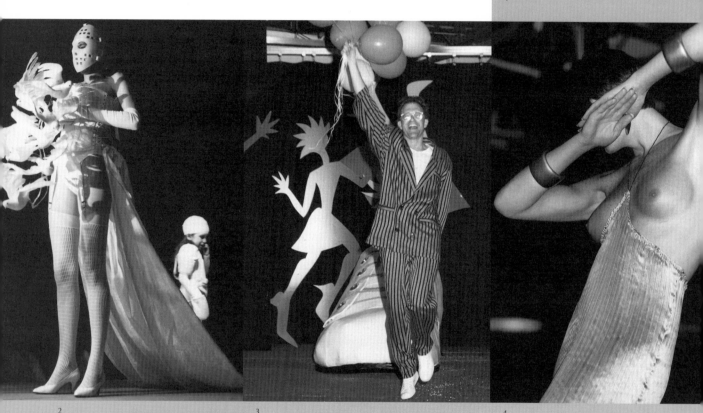

2 3 4

5

3. *Finale*
Photo: Tony Wilson
4. *Petra Chevrier modelling* Oedipus Collection *by Jamie Hart*
Photo: Anita Olanick
5. *Julie Voyce modelling* Edwardian Escapade *by Jamie Hart*
Photo: Anita Olanick

Photos courtesy Tim Jocelyn Art Foundation

the show that "*Chromaliving* is proof positive that Toronto's post-war high art traditions are dead."

Jocelyn organized the art and fashion event called *Dressing Up* for Harbourfront in 1984; it brought together a hundred artists and models to celebrate wearable art and the cult of fashion. An encapsulation in *Canadian Art* magazine described the event as "an evening designed to make high fashion look highly facile, to topple haute couture into low culture. An evening, altogether, of lunatic dionysiatrics. . . ."[5] While the premise was to give artists an opportunity to walk the runway in their creations, Jocelyn's efforts once again subversively turned notions of the sanctity of fine art on their ear.

Although Jocelyn was an impresario, he would not be comfortable given sole credit for such happenings. In fact, his energy and vision created forums for many artists and makers to come together in new ways. Lucy Lippard, in her description of similar forces at work in the New York art scene, writes: "In the early 80's, collaboration itself became a political statement, an effective way of attacking the conventional notion of rugged individual genius and of breaking down barriers between 'downtown' and 'uptown' artists."[6] Jocelyn recognized a surge of activity in the community that demanded an outlet, despite the aloof stance of the Art Gallery of Ontario and the private dealers in the city.

Jocelyn was also aware of the difficulties that his own work conjured when demanding classification by the Toronto art establishment. As a "fashion artist," he was vexed by the double standard evident in the gallery world's handling of craft. Jocelyn was conscious of the age-old schism between the fine-art and craft camps. He said, "There have always been great craftsmen involved in fashion – the lacemakers and the beadmakers. I'm quite happy to sell to the fashion market. Equally I think people in galleries can carry my work. I like to think of myself as walking a fine line. I don't like to polarize myself."[7]

He did not consider his work outside the realm of fine art, yet it was difficult for him to fit in. "I want people to approach my clothes fairly seriously because, to me, they're an art medium on the same level as sculpture or painting."[8]

Jocelyn straddled the two camps. He participated in many exhibitions at the Ontario Crafts Council, Harbourfront, at the ChromaZone venues, and even had a retrospective exhibition at the venerable Olga Korper Gallery in 1983. *Visual Rhythms*, an outdoor exhibition at the Toronto Sculpture Garden in 1984 that incorporated three huge banners by Jocelyn, furthered public familiarity with his work. He was also included in a show of Canadian design at 49th Parallel Gallery in New York in 1985. It was not until after his death, however, that the larger players – museums and public galleries – began to take notice of this important body of work. A posthumous retrospective of his work, *Fictions+Realities*, was mounted at the Power Plant in Toronto in 1990. Shows organized in conjunction with the Tim Jocelyn Art Foundation have followed at the Textile Museum of Canada, Toronto (1996), the Robert McLaughlin Gallery in Oshawa (1997), and the Macdonald Stewart Art Centre in Guelph (2000).

Sexuality was a factor in defining Tim Jocelyn's work. As a young gay male artist in the carefree heyday of pre-AIDS Toronto, he revelled in the newfound acceptance of a gay lifestyle. There is a joyous celebration of homosexuality in Jocelyn's work, a defiant, lusty playfulness that belies an assurance and confidence that were reflected in the man. It is helpful to consider his chosen medium as "queer" – breaking with tradition, alternative, undefinable. Fashion and sewing have traditionally been characterized as "women's work," but Jocelyn and other gay male Canadian artists such as Robert Windrum and Neil MacInnis have defiantly claimed the needle. MacInnis has written, "The complex

link that associates the homosexual in popular consciousness with the textile practitioner may appear to be a superficial sexual stereotype. There is, however, a verifiable history of homosexual textile practice as there are certain professions popularly associated with figures known to be homosexual."[9] In an interview, MacInnis said, "Both the domain of textiles and sexuality are informed by the conditions of habituated practice. Cultural artifacts and social interaction facilitate a meaningful history of use through sensory experience located first in the body rather than in the mind."[10]

Jocelyn explores the relationship of the garment to the body and its associated sensual, intimate qualities in his *Wild Boys Boxer Shorts* (1982, silk and leather, Collection of the Macdonald Stewart Art Centre, Guelph). The shorts are appliquéd with colourful silhouettes of burly boxers: their bodies are cut out of silk, their gloves of coloured leather. The words "WILD" and "BOYS" are writ large on the waistband of the shorts. The fetishization of the sports garment is common in gay male iconography that investigates the locker room as queer space. In another work, Jocelyn tattooed a regular grey double-breasted business jacket with black, silver, and gold decorations reassembling machine parts, a television set, and even a heart on the sleeve (*Grey Jacket*, 1984, silk and leather, Collection of Gordon Jocelyn). This uniform of conformity, normally worn in the performance of everyday tasks, suddenly becomes gloriously unique, emblematic of a queer identity – ready for monkey business.

Perhaps it was in his banners that Jocelyn's textile work came closest to painting. The flat format of a banner lends a formalism that encourages the reader to view the work as a piece of art. Of several ornate silk and leather banners produced in the mid-eighties, *Cities of the Red Night* (1984, silk and leather, 38" x 60", Collection of the Macdonald Stewart Art Centre, Guelph) is most complex. The banner takes its name from a book by William S. Burroughs (1914-1997) published in 1981. When an excerpt taken from the new book was published in FILE magazine in 1981, the editorial described it: "William Burroughs excerpts his new novel *Cities of the Red Night* and puts sex where it belongs: in public – in the bars and at hangings."[11] Jocelyn's banner brings sex into public as well. The whole banner is cut in warm to hot shades. A sinister hand holds a demonic mask on the far left, and naked men wrestle, pose, and engage with javelins and bows against a backdrop of mosques and minarets. A mysterious trio of masked figures runs arm in arm from far right through this gay nirvana. There are also sinister silver fighter jets in the sky over the city. Could these masked rogues and portents of violence signal the arrival of the AIDS plague into the gay man's playground in the eighties? The centre of the banner is dominated by a large silhouette of a muscular male figure in fiery red briefs, reminiscent of the first Calvin Klein underwear ad, which appeared in the eighties and featured model Jeff Aquilon, mostly naked against a whitewashed Grecian wall. The top and bottom are bordered by a decorative band that juxtaposes curling phalluses against a bold geometric pattern. The banner is provocative and sensual in imagery and material. It is a rigorous composition that rivals any painting in its complexity, depth of meaning, and concept.

In 1985, one year before his death, Jocelyn was commissioned to create a piece for the Canada Pavilion at Expo 86 in Vancouver. This was to be the last major project in his short career. He began exploring imagery for the project on paper, working with vinyl cutouts in the same way he had used fabric in his textile applications. What emerged was the *New Dimensions Astrolabe* (1986, vinyl cutouts, mixed media; 7.3 m x 4.9 m, Collection of the Museum of Contemporary Canadian Art, Toronto),

and it reigned over the Great Hall of the Canadian Pavilion at Expo 86.

The *Astrolabe* was based on the ancient instrument of navigation used by the explorers who "discovered" Canada. The instrument calculated direction based on the altitude of stars. Jocelyn's *Astrolabe* was made up of multifaceted concentric rings, comprising twenty-four different parts that turned slowly, programmed by a computer. Jocelyn used cool blues on one side and hot reds and yellows on the other side of the rings. The imagery incorporates motifs that are distinctly Canadian and closely tied to the natural environment: thunderbolts, a Haida mask on the visor of an astronaut's suit, snow geese, beaver, moose, a rendering of Tom Thomson's *The West Wind* painting, a deep-sea diver, and maps of an ocean floor. All of these images throb in vivid primary colours. Conceptually, the work embodies the ongoing search for a national identity that has preoccupied Canadian culture for most of the past century. Jocelyn seems to have synchronistically merged images of the natural world, cultural production from aboriginal peoples to modern artists, and images of new technologies related to space travel and communication. All of these elements blend into a rich, funky lexicon that celebrates that complex identity and reassures us of its development and longevity.

Any summary examination of the work produced by Tim Jocelyn must conclude that indeed this Icarus' ascent was quick, colourful, and brilliant. He was a magnetic artist, an inspiration, who carried many along with him on his vision quests. He forged ahead despite the inability of others to define him. And, thankfully, he left behind a wonderful body of work that is ample evidence of his unique vision, his humour, his irreverence, his pride in who he was. The Icarus myth is particularly poignant when applied to Tim Jocelyn because he fell far too soon.

It is tragic to dwell on the work that was never to be made and all that creative energy lost to Toronto's artistic community. It is better to focus on the ecstatic vitality of the objects that remain. It is better to be inspired to mark our own lives with emblems and decoration that set us apart from the everyday, using art as our wings to carry us above the predictable, the restricted, and the repressed.

NOTES

1. Beverly Bowen, "Craft Council Gallery Displaying Fashion Art," *Globe and Mail*, August 6, 1981.
2. Quoted in "Those Magnificent Men with Their Sewing Machines," *Toronto Life Fashion*, Winter 1981.
3. John Bentley Mays, "The Snakes in the Garden," in Robert Bringhurst et al. (eds), *Visions: Contemporary Art in Canada*, (Vancouver/Toronto: Douglas & McIntyre, 1983), 174.
4. John Bentley Mays, "Chromaliving Proves Traditions Are Dead," *Globe and Mail*, October 22, 1983.
5. "Tim Jocelyn's *Dressing Up*," *Canadian Art*, Fall 1984, 90.
6. Lucy Lippard, *Mixed Blessings: New Art in a Multicultural America*, (New York: The New Press, 1990), 168.
7. Quoted in Beverly Bowen, "Getting There . . . Tim Jocelyn," *Globe and Mail*, June 17, 1980.
8. Noah James, "Fashion Doubles as Art Form," *Globe and Mail*, June 30, 1981.
9. Neil MacInnis, "Crimes Against Nature," in Ingrid Bachmann and Ruth Scheuing (eds), *Material Matters: The Art and Culture of Contemporary Textiles* (Toronto: YYZ Books, 1998), 226-27.
10. Neil MacInnis, quoted in an interview with Margo Messing, cited in Janis Jefferies, "Autobiographical Patterns," *Material Matters*, 116.
11. FILE, vol. 5, no. 1, March 1981, 13.

TIM JOCELYN: A Chronology

1952 Born September 19 in Ottawa, the second of four children to Gordon and Joy Jocelyn.

1970 Graduates from Malvern Collegiate Institute, Toronto, and embarks with family on European vacation.

1971 Arrives in Kathmandu, Nepal.

1972 Returns to Toronto.

1975 Completes one-year General Art studies, Central Technical High School.

1976 Mother Joy Jocelyn dies of cancer, June 3.

1979 *Ontario Crafts '79* exhibition at Ontario Crafts Council.

1980 Exhibits in *New Art Wearables*, Grange Gallery, and *Fashion Art '80*, Harbourfront. Meets Andy Fabo and newly formed ChromaZone collective.

1981 Participates in six exhibitions, including solo show at Julie Artisans Gallery, New York. Curates *The Fashion Show*, ChromaZone, at the Theatre Centre, Toronto.

1982 Participates in the Clairol Fashion Awards Show, Convention Centre, Toronto. Exhibits in four group shows, including *Monumenta*, YYZ & ChromaZone, Toronto.

1983 Curates *Chromaliving* with Andy Fabo, ChromaZone, at the Colonnade. Has solo exhibition at the Olga Korper Gallery, Toronto.

1984 Curates *Dressing Up*, Harbourfront Art Gallery. Installs *Visual Rhythms* at the Toronto Sculpture Garden. Participates in six group exhibitions.

1985 Moves to New York City with Andy Fabo. Receives CIL commission for the Canadian Pavilion, Expo 86. Participates in three group exhibitions, including *Phoenix* at the 49th Parallel, New York, *Fire and Ice*, Galerie Walcheturm, Zurich. Has solo exhibitions in New York and Burlington. Represented by Reactor Art & Design, Toronto.

1986 Returns to Toronto and installs *New Dimensions Astrolabe* at Expo 86. Older sister Paula Jocelyn dies in August. Tim dies December 10, of AIDS-related illness.

Posthumous Exhibitions

1990 *Fictions+Realities*, The Power Plant, Toronto

1996 *The Tim Jocelyn Collection*, The Museum for Textiles, Toronto
 Oh Canada, Art Gallery of Ontario, Toronto
 Reviews, Mercer Union, Toronto
 Re/Grouping: A Living Legacy, McMichael Canadian Art Collection, Kleinburg

1997 *The Tim Jocelyn Collection*, Robert McLaughlin Gallery, Oshawa

1998 *Museologic*: Art Gallery of Mississauga, Mississauga
 SALON Archive Project, Visual Aids, New York

2000 *Tim Jocelyn & ChromaZone*, Macdonald Stewart Art Centre, Guelph

PORTFOLIO

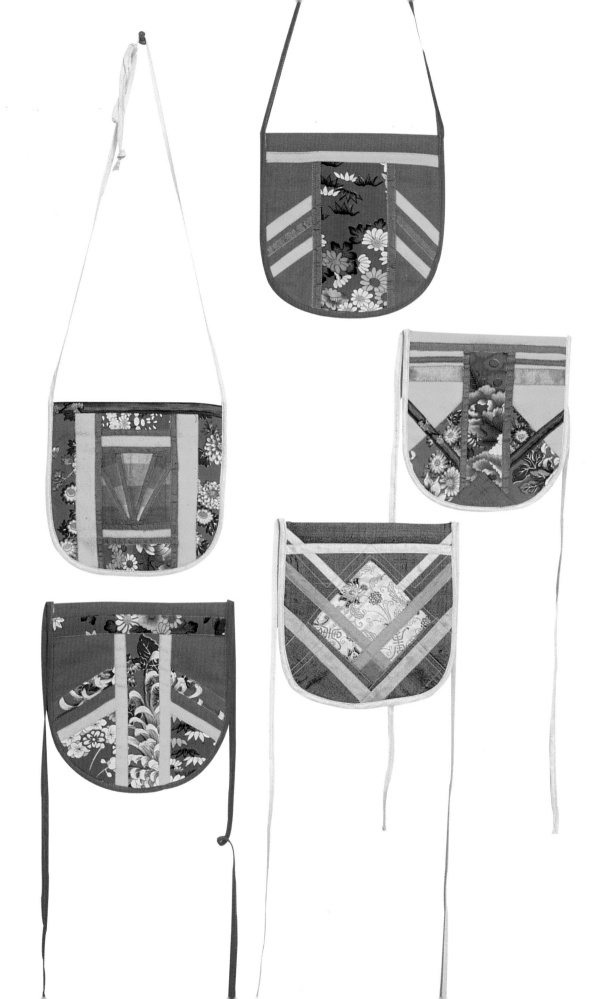

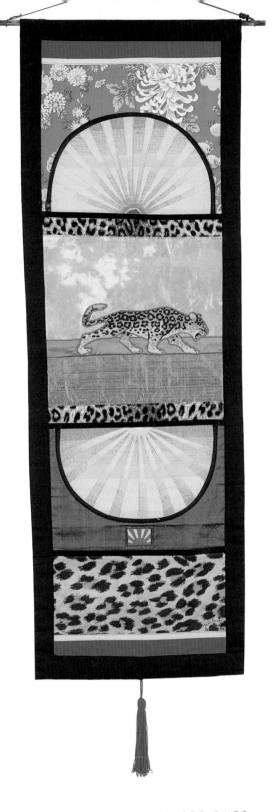

Plate 11 (opposite). DISCO BAGS

silk appliqué, c. 1979 / Collection: Tim Jocelyn Art Foundation

Plate 12. LEOPARD BANNER

silk and leather, 41" x 32", 1980 / Photo: Michael Rafelson / Collection: Cambridge Galleries, Cambridge

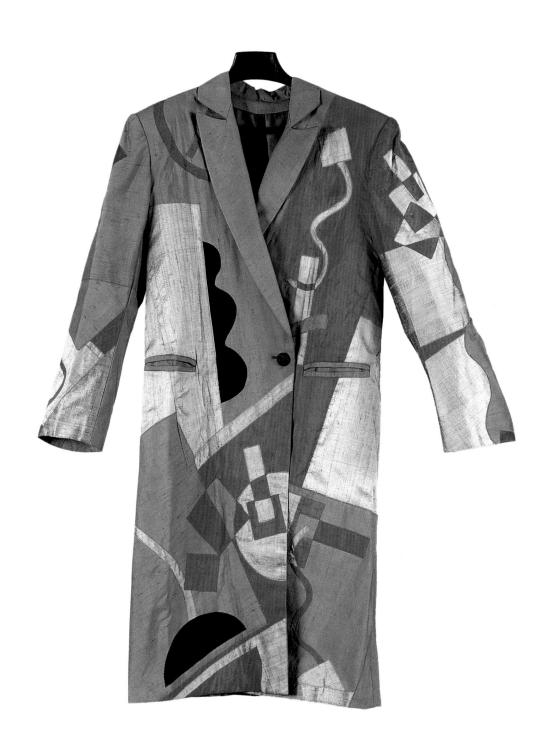

Plate 13. CONSTRUCTIVIST COAT

silk, 1980 / Photo: Michael Rafelson / Collection: Macdonald Stewart Art Centre, Guelph

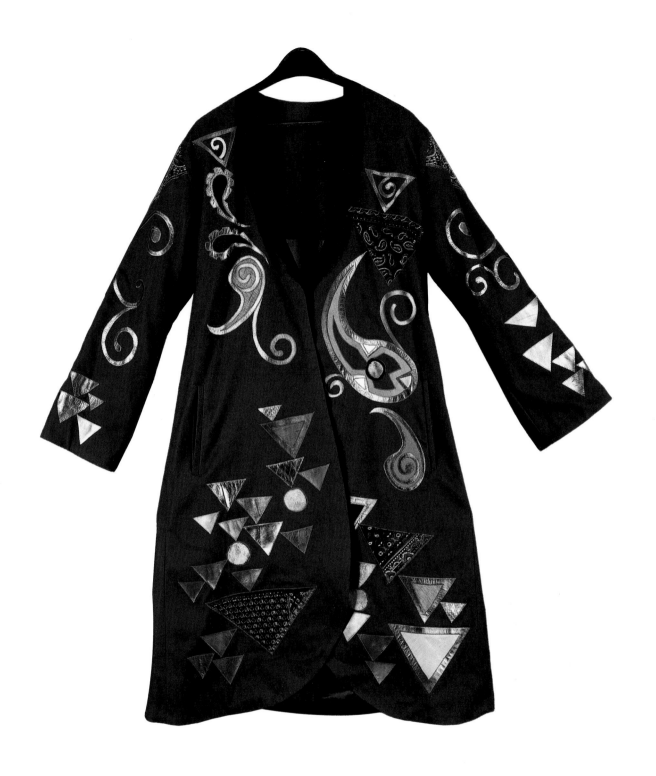

Plate 14. GREEN CONSTRUCTIVIST COAT

silk, leather, and wool, 1980 / Photo: Michael Rafelson / Collection: Cambridge

Galleries, Cambridge / Courtesy Tim Jocelyn Art Foundation

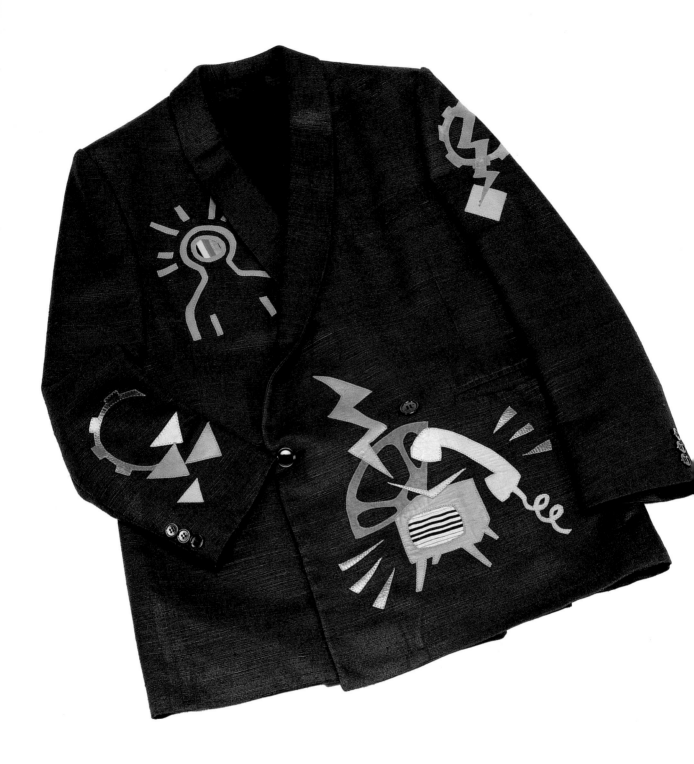

Plate 15. BLACK SUIT

silk and wool, 1982 / Photo: Michael Rafelson / Collection: Gordon Jocelyn / Courtesy Tim Jocelyn Art Foundation

Plate 16 (opposite). OOGA BOOGA DRESS

*silk and leather, 1984 / Photo: George Whiteside, 1990 / Collection: Cambridge
Galleries, Cambridge / Courtesy Tim Jocelyn Art Foundation*

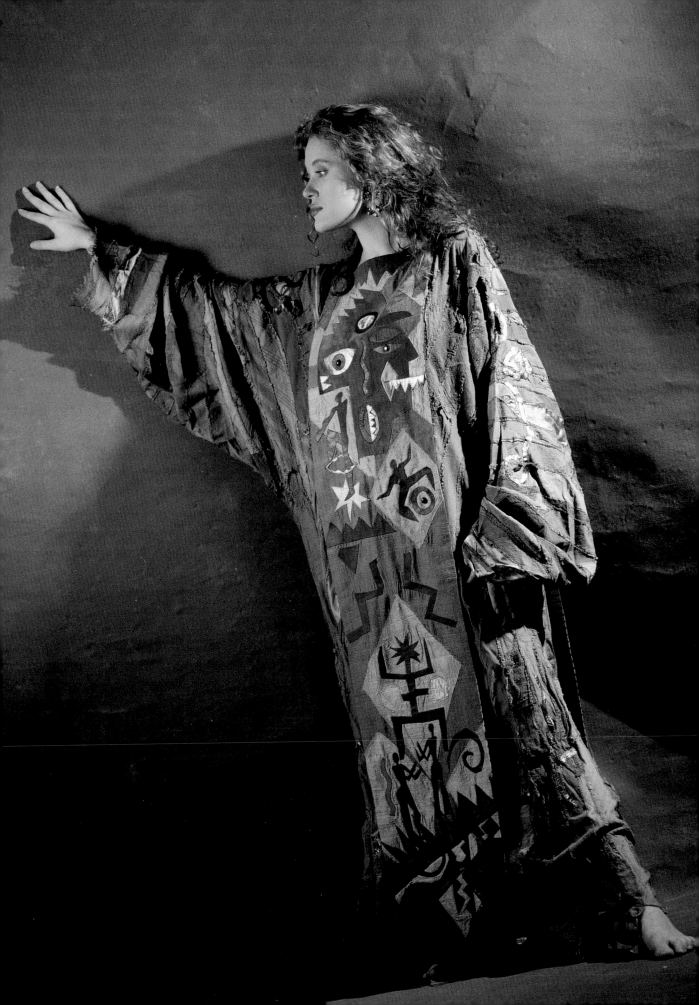

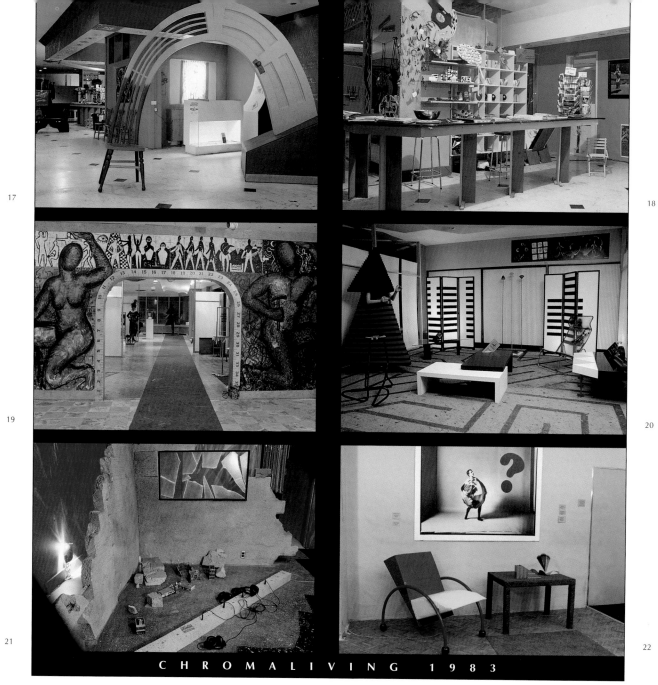

CHROMALIVING 1983

Plate 17. ENTRANCE
John MacGregor, Chair Turning
 into a Door

Plate 18. BOUTIQUE
Adele Steinberg, earrings
Melanie Chikofsky, Painted Hats
Helen Chikofsky, Ceramic Tea Set
Alta Louise Doyle, Atrophied Ritual
Matt Harley, Sweatshirts

Margaret Malouf, Ceramics
XOX, Postcard Rack

Plate 19. MAIN ARCHWAY
Tony Wilson, Work to Rule

Plate 20.
General Idea, V.B. Gown No.1
Blair Benoit, Drawing Stool
Michael Robertson, Neo-Constructivist
 Table, Kinetic Coffee Table

Plate 21. OFFICE
Randy & Berenicci, Catastrophe
 Theory, office installation

Plate 22.
W.S. Brown, "?"
Loris Calzolari, Comet
Peter Gray, Table
Margaret Malouf, Shoe Vase

Photos this page: Isaac Applebaum
Courtesy Tim Jocelyn Art Foundation

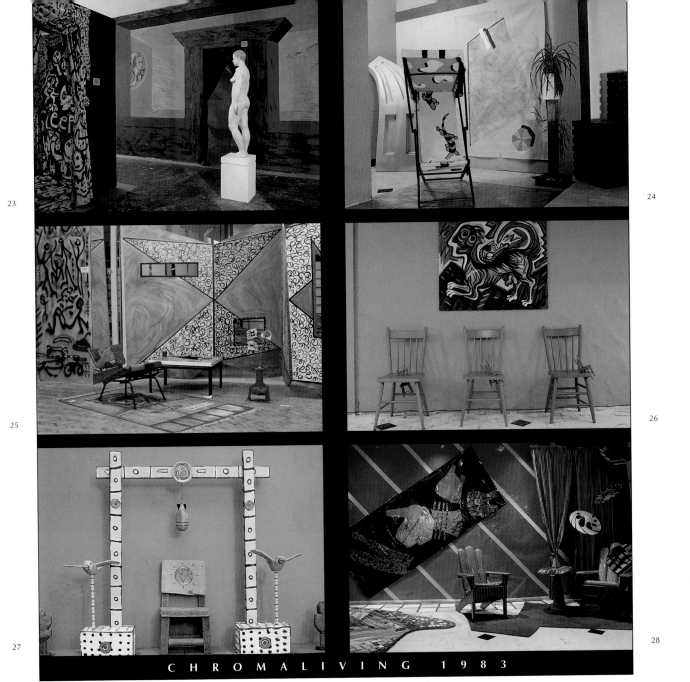

CHROMALIVING 1983

Plate 23.
Evan Penny, Janet
John Scott and Elinor Rose Galbraith,
 Bunny Boudoir
Brian Video, Piazza Mural

Plate 24.
John MacGregor, Curved Door
Tom Slaughter, Summer
Jim Anderson, Harry
Judith Schwarz, Porch Life *(detail)*

Plate 25.
Duncan Buchanan, Chromagene
Andy Fabo, Convicts Chair & Rug
David Morrison, Above the Ozone
John Pagai, Use It
Catherine Carmichael, untitled

Plate 26.
Derek Caines, Dogsound
John MacGregor, Six Chairs

Plate 27.
Brent Roe, The Last Chair on Earth

Plate 28.
David Buchan, From the Archive of
 Lamont del Monte
Peter Gray, Party Chairs, Party Table,
 Red Striped Drapes
Melanie Chikofsky, Painted Straw Hats
Kim Kozzi, Popeye Polemics

Photos this page: Isaac Applebaum
Courtesy Tim Jocelyn Art Foundation

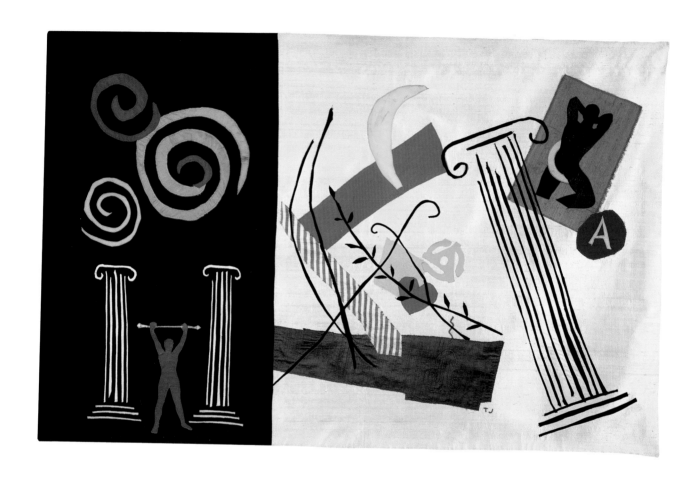

Plate 29. POSTCARD FOR A

silk and leather, 38" x 54", 1982 / Photo: Michael Rafelson / Collection: Art Gallery of Mississauga, Mississauga

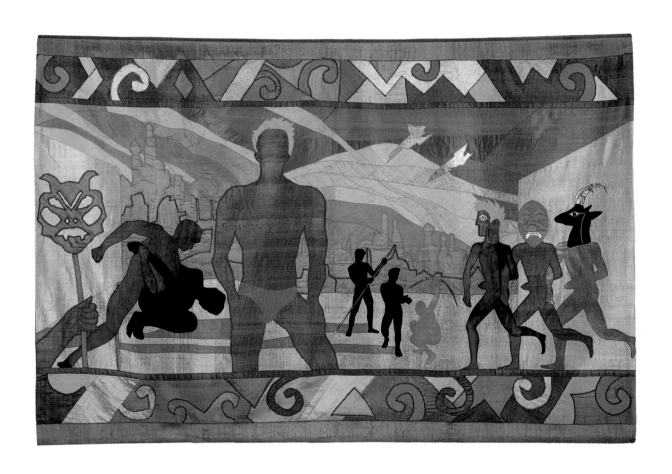

Plate 30. CITIES OF THE RED NIGHT

silk and leather, 38" x 60", 1982 / Photo: Michael Rafelson / Collection: Macdonald Stewart Art Centre, Guelph

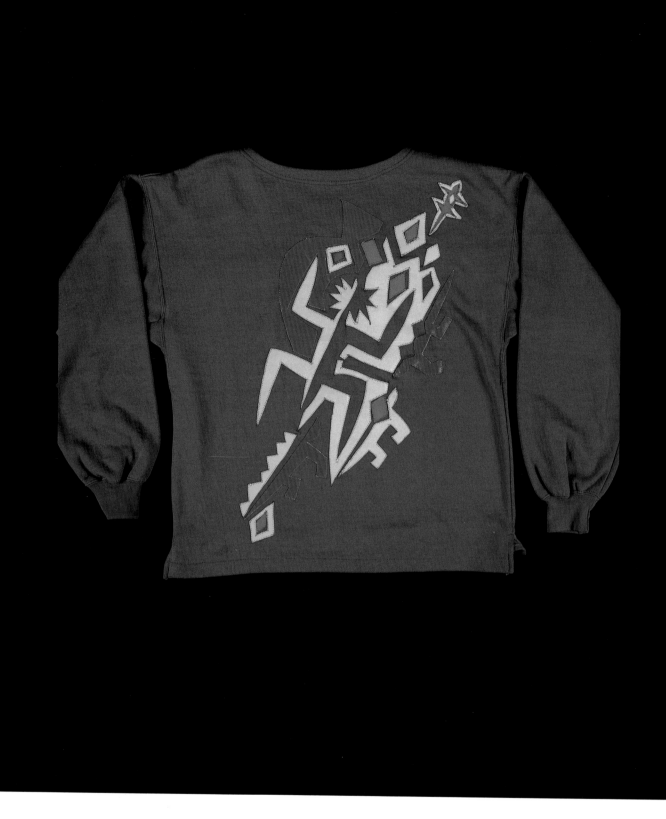

Plate 31. BLUE SWEATSHIRT

leather and cotton, c. 1982 / Photo: Michael Rafelson / Collection: Gordon Jocelyn, Toronto

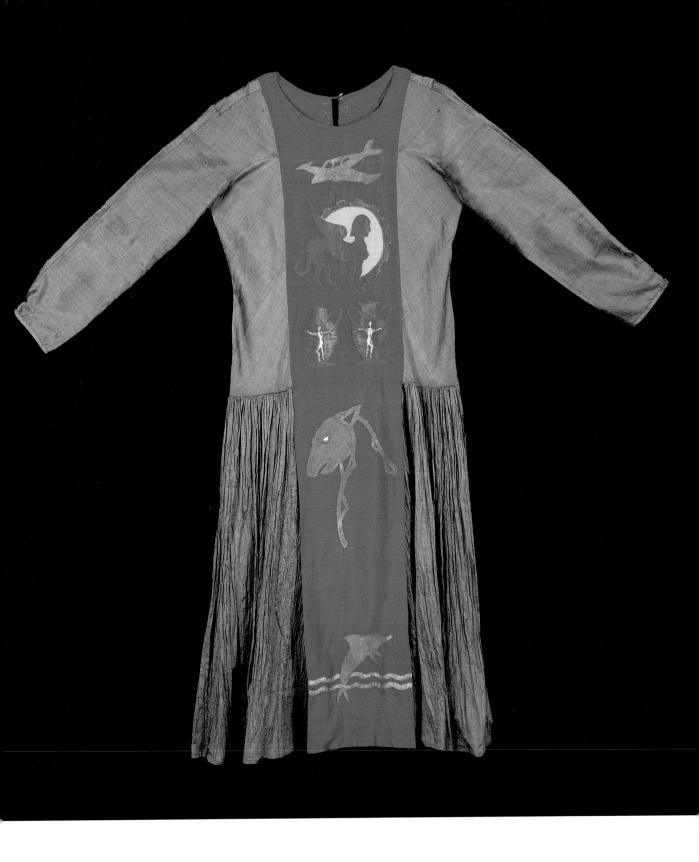

Plate 32. FLORENTINE DRESS (front)

silk and leather, 1983 / Photo: Michael Rafelson / Collection: Macdonald Stewart Art Centre, Guelph

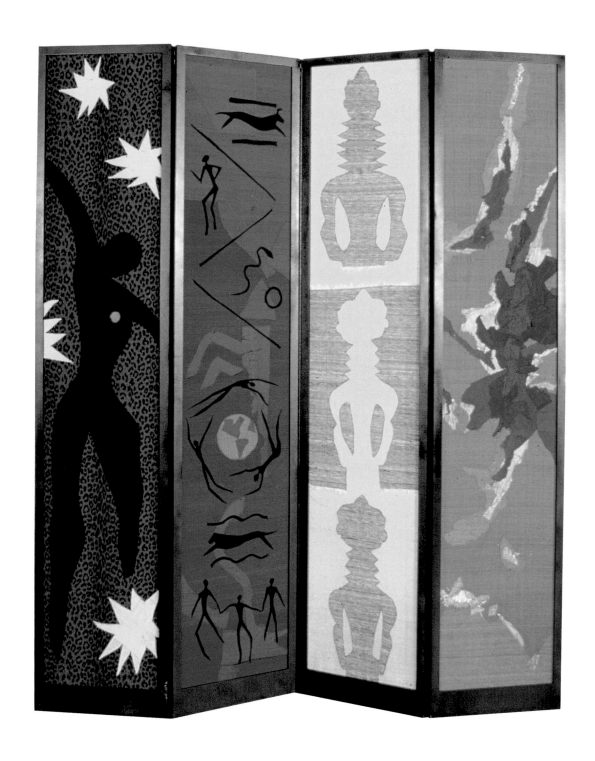

Plate 33. UNTITLED (MATISSE)

silk and leather, 65" x 16" x 4, 1983 / Photo: Tony Wilson / Collection: Cambridge Galleries, Cambridge /
Courtesy Tim Jocelyn Art Foundation

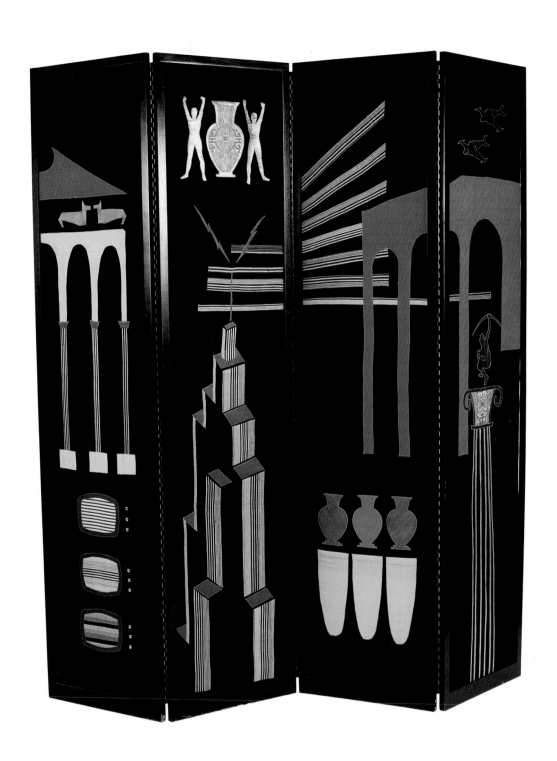

Plate 34. POST-METROPOLIS

silk, leather, and wood, 72" x 18" x 4, 1983 / Photo: Michael Rafelson / Collection: Macdonald Stewart Art Centre, Guelph

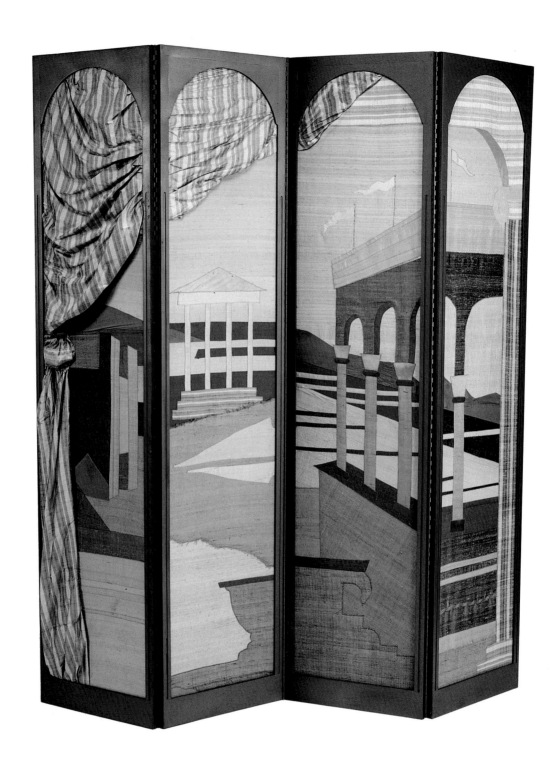

Plate 35. NAPOLI

silk, leather, and wood, 72" x 18" x 4, 1983 / Photo: Michael Rafelson / Collection: Tim Jocelyn Art Foundation

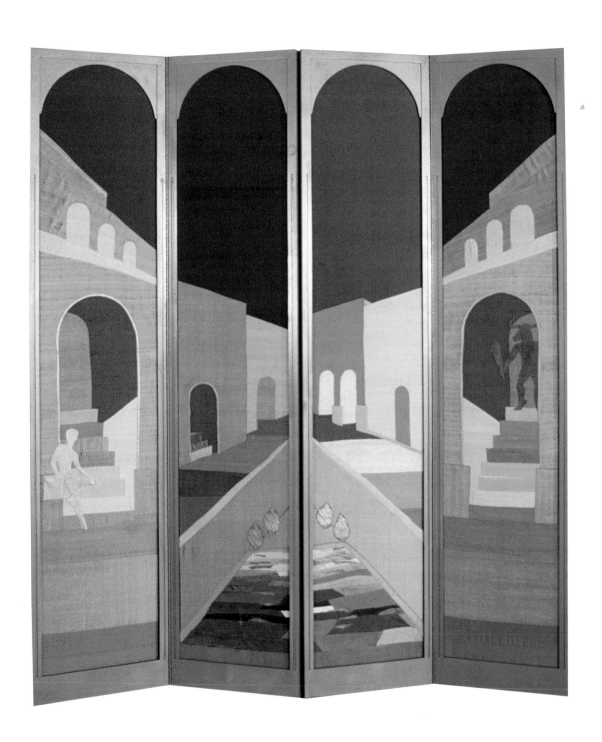

Plate 36. THESEUS

silk, leather, and wood, 72" x 72" x 4 / Photo: Tony Wilson / Courtesy Tim Jocelyn Art Foundation

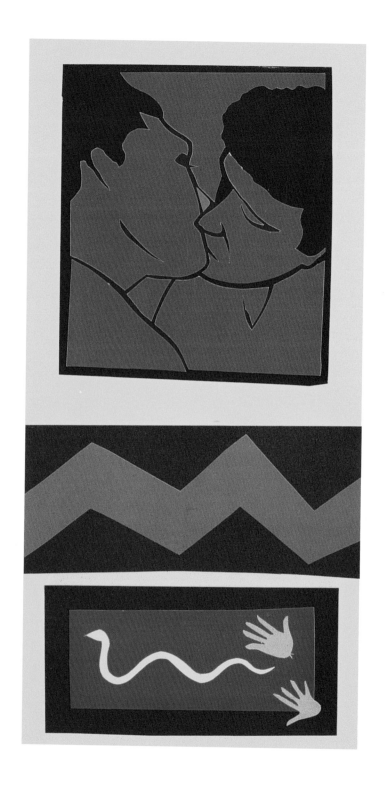

Plate 37. POINT OF CONTACT

papercut, 46" x 32", 1984 / Photo: Tony Wilson / Courtesy Tim Jocelyn Art Foundation

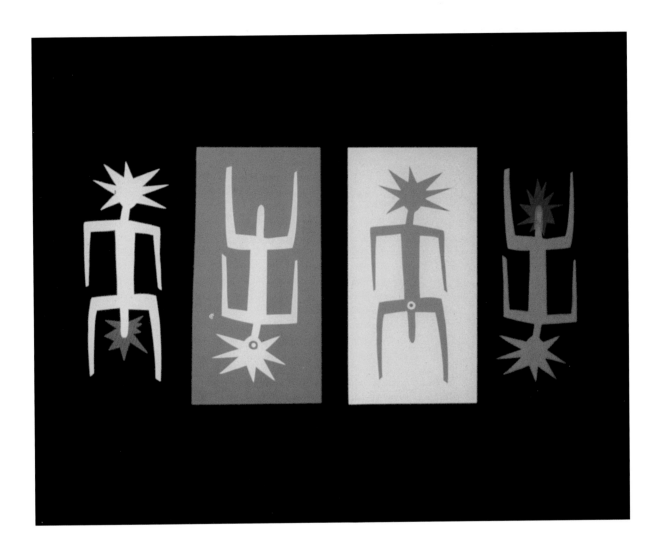

Plate 38. DESIRE

papercut, 32" x 40", 1984 / Photo: Tony Wilson / Collection: Tim Jocelyn Art Foundation

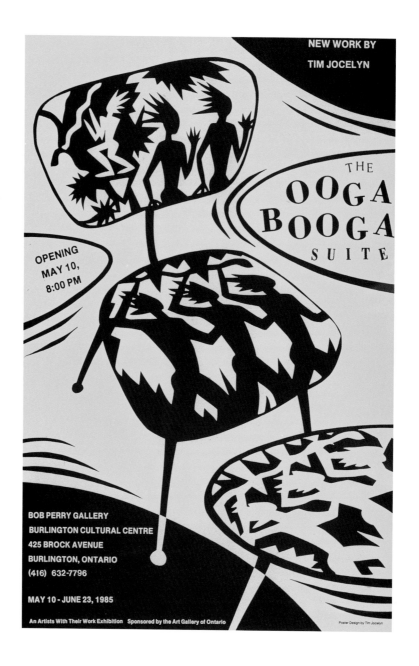

Plate 39. OOGA BOOGA SUITE POSTER

Art Gallery of Ontario, Extensions Program / offset, 11" x 17", 1985
Design: Tim Jocelyn / Collection: Tim Jocelyn Art Foundation

Plate 40 (opposite). OOGA BOOGA SUITE – CHAIR

leather and metal, 1984 / Photo: George Whiteside / Collection: Tim Jocelyn Art Foundation

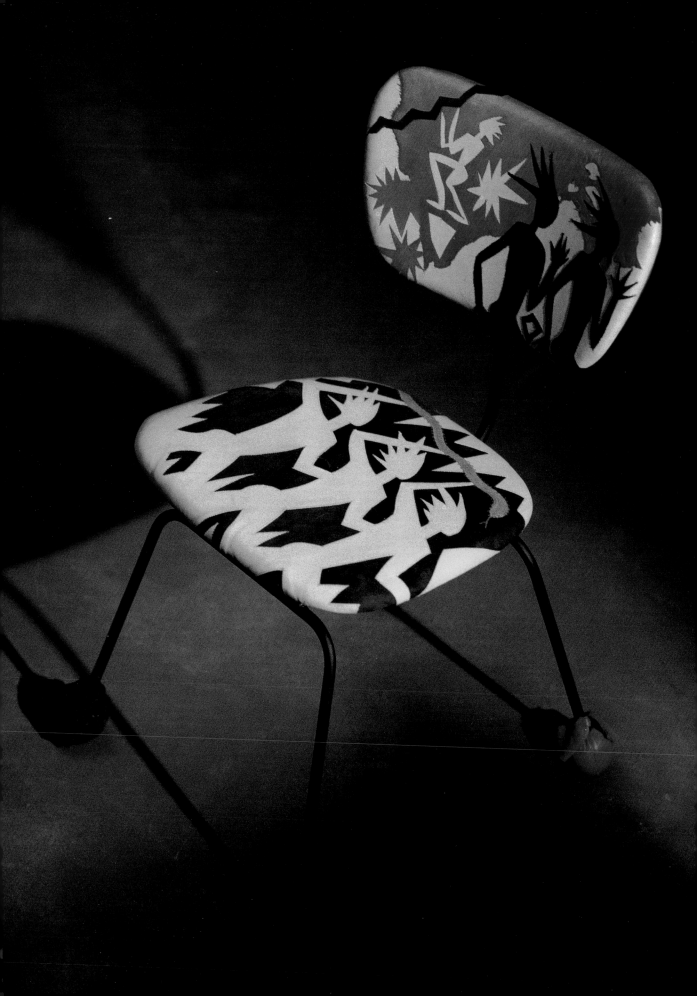

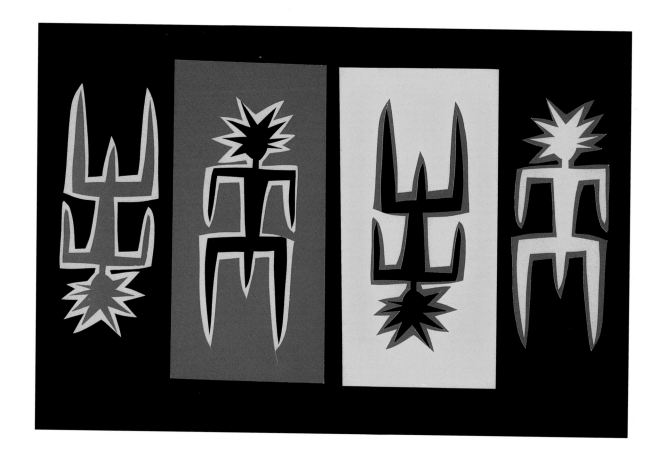

Plate 41. DESIRE

papercut, 1984 / Photo: Tony Wilson / Collection: Tim Jocelyn Art Foundation

Plate 42 (opposite). LIZARDS

chenille rug maquette, papercut, 13" x 17", 1985 / Photo: Michael Rafelson / Collection: Tim Jocelyn Art Foundation

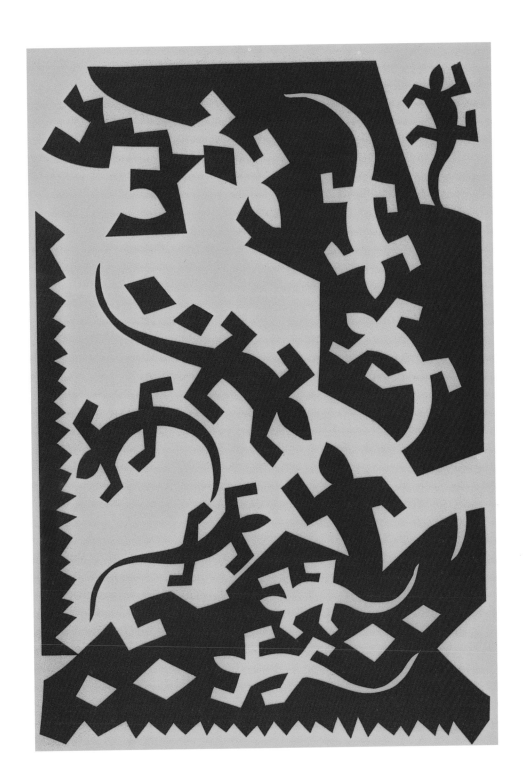

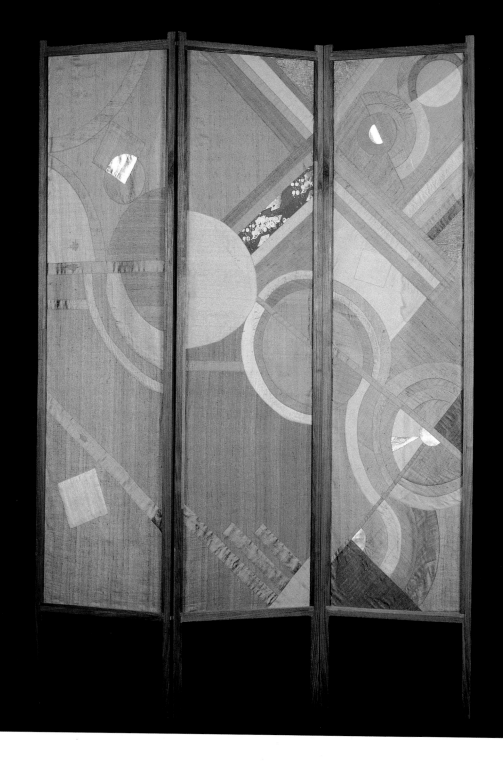

Plate 43. KANDINSKY SCREEN

silk, leather, and wood, 60" x 16" x 3, 1980 / Photo: Michael Rafelson / Collection: Cambridge Galleries, Cambridge

Plate 44 (opposite). OOGA BOOGA SCREEN (front)

Tim Jocelyn and Tom Slaughter

silk, leather, and wood, 60" x 16" x 3, 1984 / Photo: Michael Rafelson /
Collection: Marthe Jocelyn and Tom Slaughter, New York

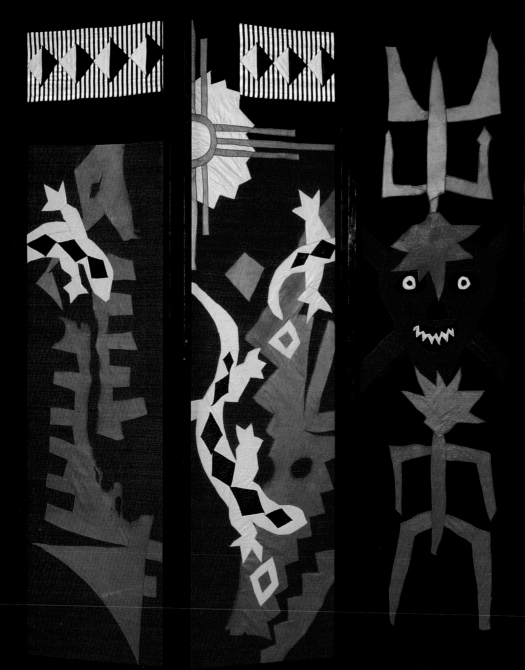

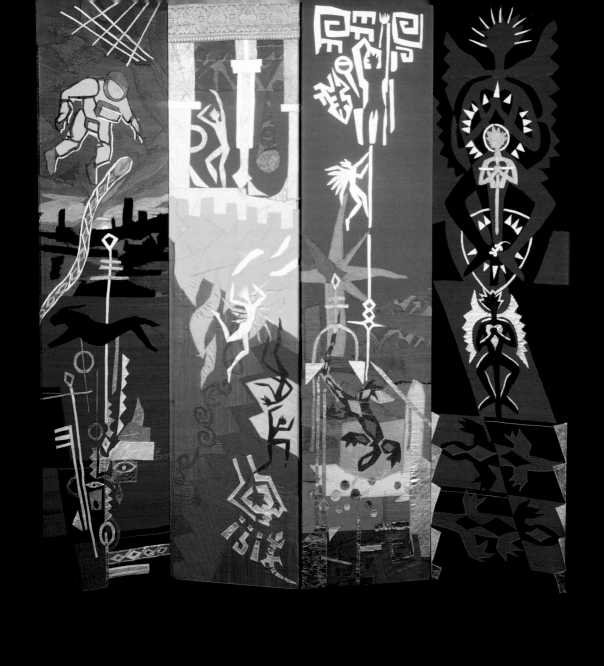

Plate 45. RE-SIGNING ICARUS

Ascension of Icarus, Descent of Icarus, Beatification of Icarus, After Icarus

silk and leather, 65″ x 16″ x 4, 1985 / Photo: Michael Rafelson / Collection: Macdonald Stewart Art Centre, Guelph

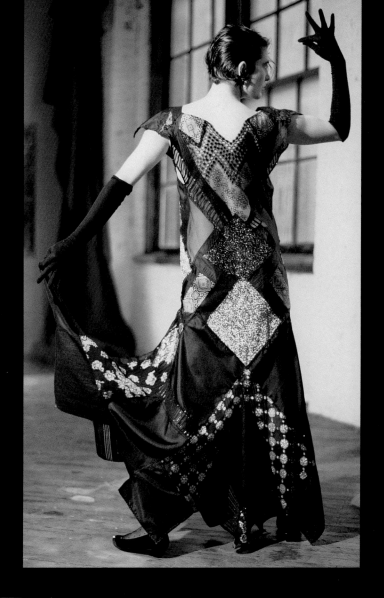

Plate 46. BLACK LACE DRESS

silk and lace, 1984 / Model: Kim Angliss / Photo: Tony Wilson / Collection: Tim Jocelyn Art Foundation

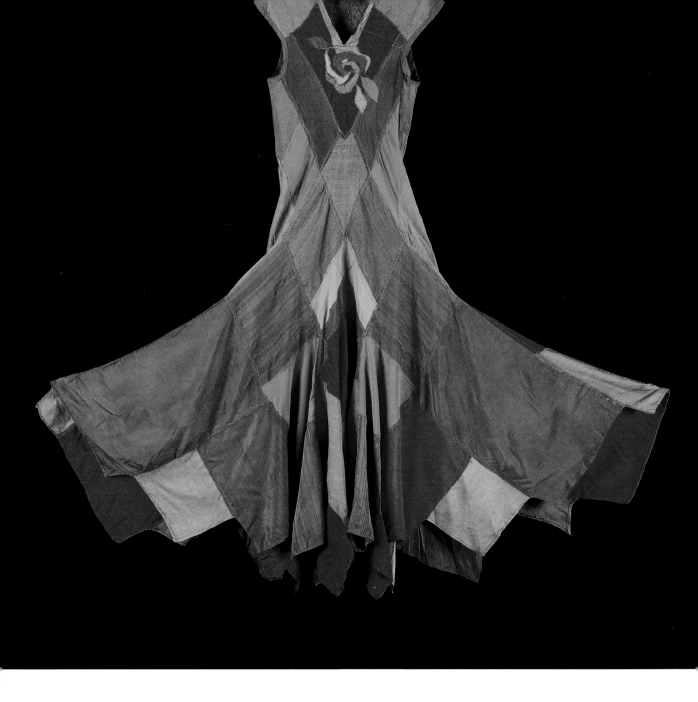

Plate 47. RED SILK DRESS

silk, 1985 / Photo: Michael Rafelson / Collection: Tim Jocelyn Art Foundation

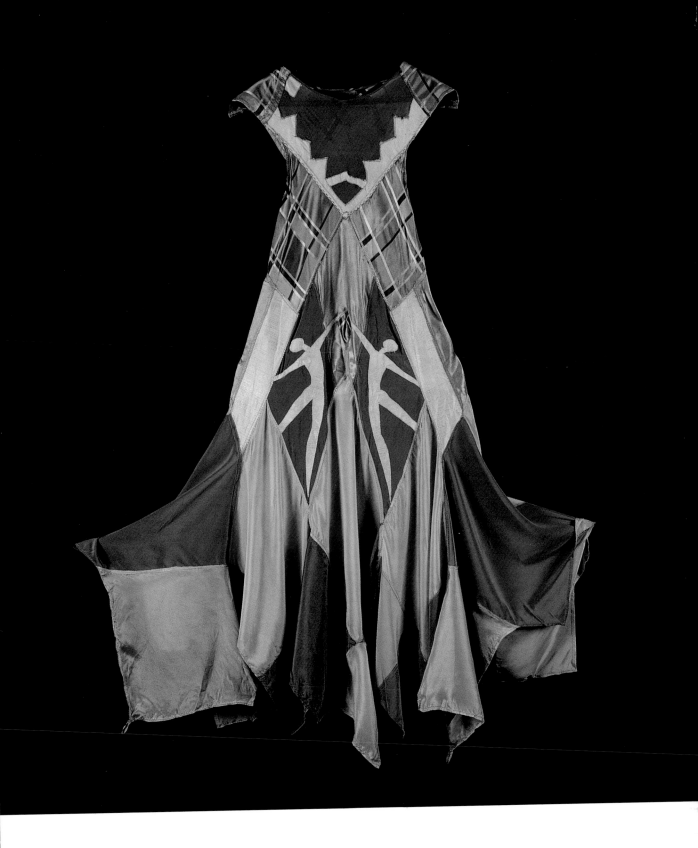

Plate 48. PINK & BLUE TEA DRESS

silk, 1985 / Photo: Michael Rafelson / Collection: Tim Jocelyn Art Foundation

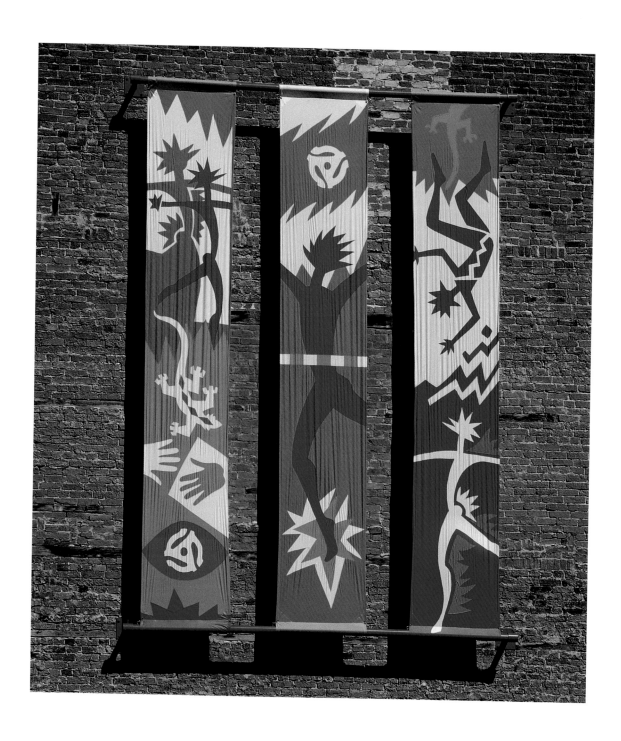

Plate 49. LIZARD BOYS OOGA BOOGA

Installation at the Toronto Sculpture Garden / ripstop nylon, 213" x 36" x 3, 1984

Collection: Louis Fishauf and Tim Jocelyn Art Foundation

Plate 50. PAM AM ZIMBU ZIMBU OOGA BOOGA

papercut, 32" x 28", 1984 / Photo: Michael Rafelson

Collection: National Gallery of Canada, Ottawa

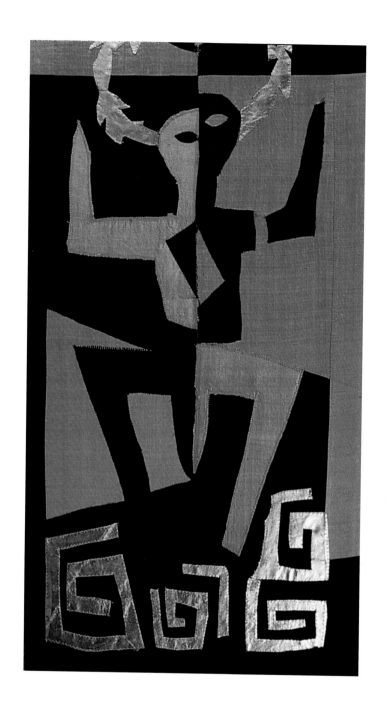

Plate 51. OOGA BOOGA PANEL

silk and leather, 50" x 15", 1984 / Photo: Tony Wilson / Collection: Gordon Jocelyn, Toronto

Plate 52 (opposite). OOGA BOOGA SUITE

silk and leather, 50" x 45", 1985 / Photo: Michael Rafelson / Collection: Tim Jocelyn Art Foundation

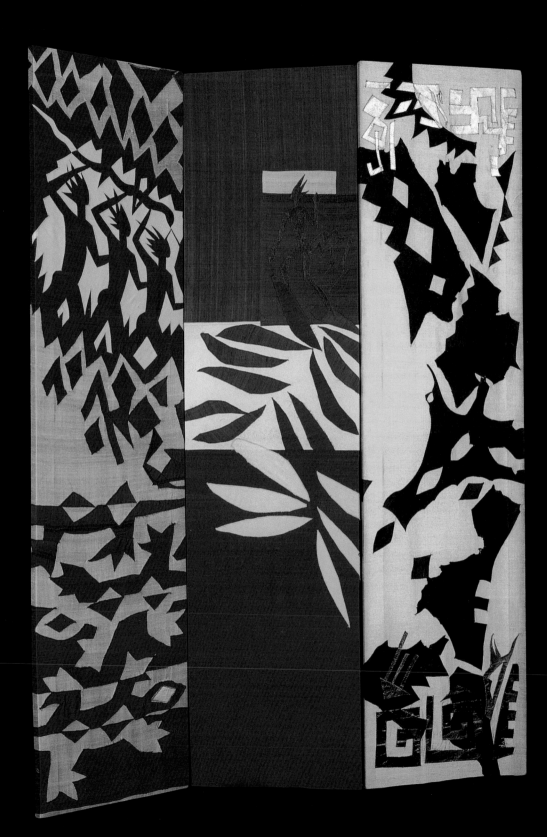

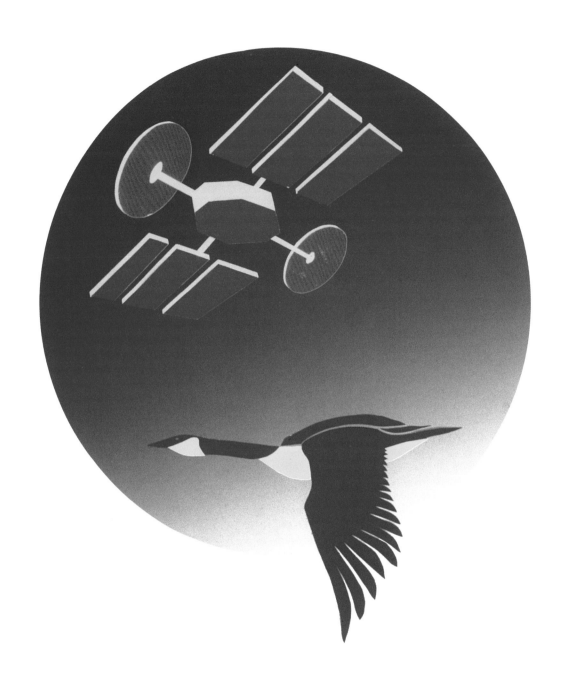

Plate 53. OUR HOME & NATIVE GOOSE

papercut, 20" x 17", 1985 / Photo: Tom Moore / Collection: Robert McLaughlin Gallery, Oshawa

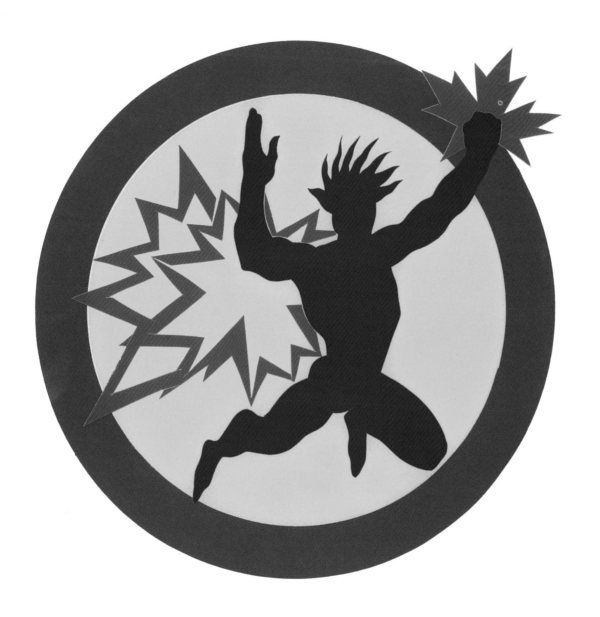

Plate 54. CAPTAIN CANADA

papercut, 11" diameter, 1985 / Photo: Michael Rafelson / Collection: Macdonald Stewart Art Centre, Guelph

Plate 55 (following page). ICARUS IN ECSTASY

postcard, 7 3/4" x 4 1/4" 1985 / Collection: Tim Jocelyn Art Foundation

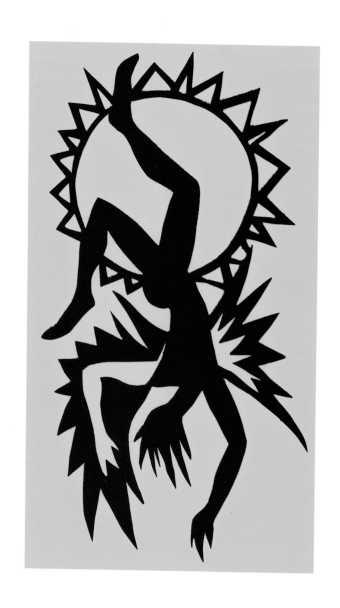